IMAGES
of America

SEASIDE
1920–1950

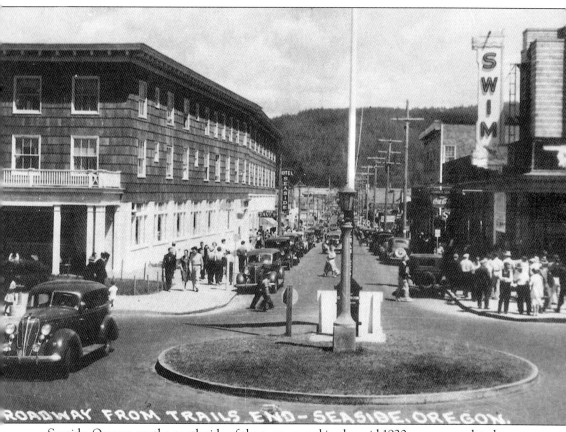

Seaside, Oregon, on the north side of the turnaround in the mid-1920s, accommodated two-way traffic. To the left is the Hotel Seaside, and in the background is the Oates Natatorium. (Courtesy of the Seaside Historical Society.)

ON THE COVER: The Seaside turnaround at the end of Broadway Drive has been a major tourist attraction since being built, as seen in this William Montag photograph. (Courtesy of the Seaside Historical Society.)

IMAGES
of America

SEASIDE
1920–1950

Susan L. Glen

Copyright © 2007 by Susan L. Glen
ISBN 978-0-7385-4894-4

Published by Arcadia Publishing
Charleston SC, Chicago IL, Portsmouth NH, San Francisco CA

Printed in the United States of America

Library of Congress Catalog Card Number: 2007921325

For all general information contact Arcadia Publishing at:
Telephone 843-853-2070
Fax 843-853-0044
E-mail sales@arcadiapublishing.com
For customer service and orders:
Toll-Free 1-888-313-2665

Visit us on the Internet at www.arcadiapublishing.com

This book is dedicated to the people of Seaside, Oregon.

CONTENTS

Acknowledgments		6
Introduction		7
1.	Changes at the Turnaround	9
2.	Business as Usual	25
3.	Fun and Festivities	69
4.	War Years	97
5.	People	105

Acknowledgments

This book would not have been possible without the help of Barbara Cook and Ella Beigh at the Seaside Historical Society, which welcomes contributions to their photographic collections. Pictures were scanned from the files of the Seaside Historical Society and from the private collections of Edna Marie Thorn, Roy Mannila, Ed Rippett, Ray Dodge, Alice Hermann, Joan Luper, Jeanne Anderson, Kathleen Grimm, Harold Lampe, Mary Cornell, Jean TerHar, Lester U. Raw II, and the Seaside Christian Church. The photographs from Edna Marie Thorn were originally from the Montag and Hale collections, as her father, Leslie Hale, was the photographer who purchased William Montag's business at the turnaround.

INTRODUCTION

Following the fire of 1912 that leveled Seaside, a resurgence began that created the town the reader will discover in the following pages.

Seaside derived its name from the Seaside House built by Ben Holladay on the south end of town, which is now the site of the Seaside Golf Course. The area that became the town was made up of West Seaside and Seaside, and they merged in 1913. Finntown included an area that extended on the east side of the railroad tracks from Avenue F to Avenue M. There was a high, wooden plank bridge connecting Finntown with the other side of the river. To the east of the Wahanna River, now called the Neawanna, was the property of the John Sundquist family. Many dairies and a couple of chicken farms soon occupied the area that is now home to the Seaside Providence Hospital, Seaside Heights Elementary School, and several developments.

The first town reservoir was located here on the Olson farm, but it was soon not producing enough water for the rapidly growing town. The water from the creek was so pure that the Ostman Dairy used it in their milk process. In 1925, the city installed their first municipal water system.

Tourists arrived by train until Highways 101, the Roosevelt Coast Military Highway, and Route 26, Wolf Creek Highway, were completed to allow travel by car to and from Portland, Astoria, and points south.

In 1921, the wooden boardwalk that stretched along the beach was replaced by a concrete promenade and a turnaround at the end of Broadway Drive. Broadway Drive had been previously known as Shell Road, due to its pavement of shells, then Bridge Street until finally becoming Broadway Drive in 1908. A bridge was erected on Broadway Drive to cross the Necanicum River in 1923.

Another fire broke out on September 26, 1924, destroying the J. W. Bartlett Variety Store, E. W. Lettin plumbing, the Chowder Bowl, and a boathouse on the west side of the Necanicum River bank. In September 1925, fire broke out in the Hippodrome Dance Hall, burning it, a grocery store, pool hall, and delicatessen to the ground. Residents feared the fire would once again consume the entire town. The Gilbert Building, constructed in 1915 at the corner of Seventh Street, now Holladay Drive, and Broadway Drive caught fire in February 1939. The fire destroyed the Graham Drug Company, E. C. Smith electrical shop, Lou Henry's Barber Shop, and the Safeway grocery store. Walker Bakery suffered slight damage, and the post office, also located in the Gilbert Building, escaped damage.

Logging was a major industry in the community with many small camps located in the surrounding area. W. T. Gable, later known as Clark Gable, lived with the Schumann family in Seaside in 1922 while working for one of the logging companies. In 1934, Crown-Willamette took over the operations of the LeDee Logging Company. A strike by the Timber and Sawmill Workers Union in 1935 idled many workers and lead to several riots. Unfortunately, pictures from this era have not been found yet. One logger told a story about one of the riots beginning because workers saved up orange peels from their lunches and threw them at the "scabs" out by the "red" bridge east of town.

Floatplanes began landing in the Necanicum River, also used for recreational boating, crabbing, and fishing, in March 1920, and later airplanes landed on a landing strip on the beach, bringing copies of the *Oregon Journal* and offering rides for $3. Scheduled airplane service began in June 1921, and the Seaside Airport was established in its current location in the 1950s. Although the Great Depression downsized the population of Seaside, its impact on the town was minimal. The Seaside bank had gone broke for a second time in 1927, but by the mid-1930s, businesses and population were growing, and tourism had increased.

World War II brought blackouts and military patrols to the community. The shelling of Fort Stevens in Hammond was heard by the Seaside residents. Blimps patrolled the coast and were often seen passing the turnaround. Women joined the ambulance corps, and rationing created some interesting trading of goods among the local businesses. Excess flour at the candy store was traded for excess sugar at the bakery. A new hospital was built in 1945, and the new Seaside High School opened. In 1946, the Miss Oregon Pageant began in Seaside and continues to be a highlight of the year.

Dance halls and dance bands, skating rinks and swimming pools, along with amusement parks, the merry-go-round, and many other attractions, continued to bring the tourists to the community. Seaside grew and flourished.

Surely there are many events yet to be uncovered, but the hope is that the pictures and captions on the following pages will help revive Seaside during the years 1920 to 1950.

One
CHANGES AT THE TURNAROUND

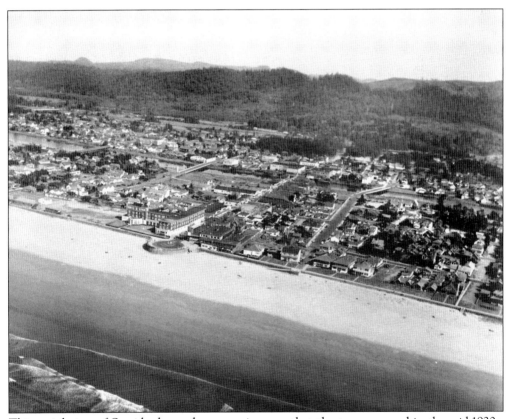

This aerial view of Seaside shows the expansive area that the town covered in the mid-1920s. Note that the promenade did not extend as far to the north as it did to the south. Although the promenade was 5,000 feet in the beginning, it was later extended to 8,000 feet. The Seaside Hotel next to the turnaround had already become the focal point of the city. (Courtesy of Edna Marie Thorn.)

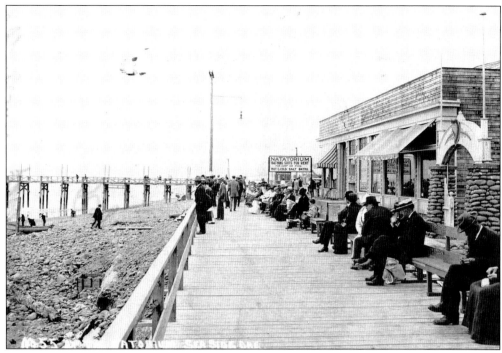

Built in 1908 along 8,010 feet of beachfront area, the old wooden boardwalk was still in place in 1920. A fishing pier extended into the surf and provided recreation for the many tourists who flocked to the coast by train. The beach was rocky and often strewn with logs. (Courtesy of the Seaside Historical Society.)

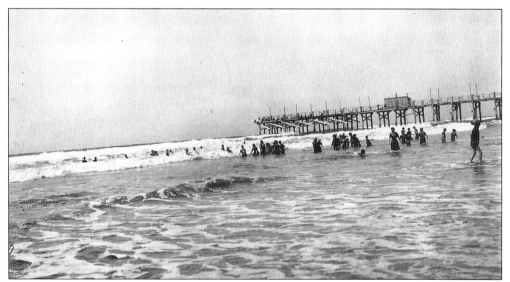

Around 1921, a recreation pier was built from the foot of Broadway Drive a quarter mile out into the breakers. Like the piers before it, the structure provided a place to fish, sit, and watch the ocean. (Courtesy of the Seaside Historical Society.)

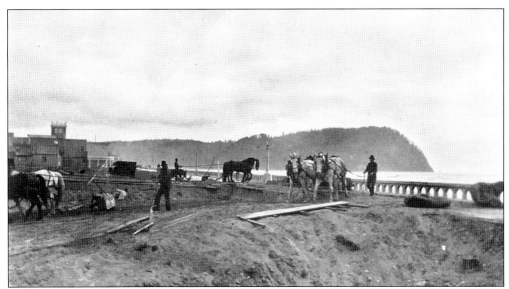

City engineer L. C. Rodgers was the architect who created the plans to build a turnaround at the foot of Broadway Drive in conjunction with the concrete promenade, and construction began in April 1921. Horse teams were used in preparation for putting in the concrete. The diameter of the circle was to be 108 feet with 25-foot driveways. A concrete rail 30 inches high was placed around the circle. (Courtesy of the Seaside Historical Society.)

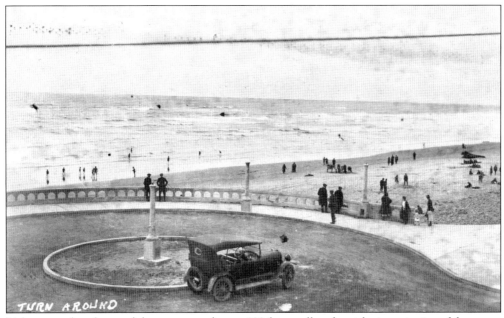

Lights were placed around the turnaround every 100 feet to allow for nighttime viewing of the ocean and beach, and the sidewalks were to be 14 feet wide. Restrooms were put beneath it to facilitate the increasing tourist population's needs. (Courtesy of the Seaside Historical Society.)

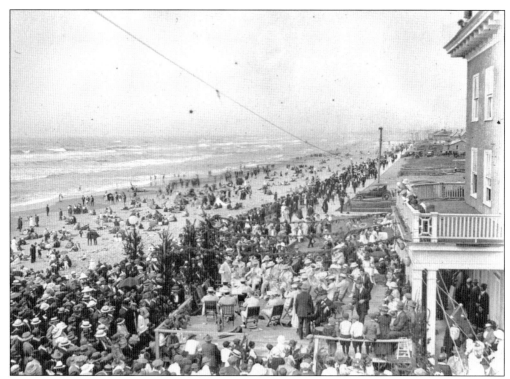

On August 8, 1921, the dedication ceremony of the completed seawall in front of the Hotel Seaside was attended by thousands of people and dignitaries from across the area. (Photograph courtesy of the Seaside Historical Society and Mrs. E. U. Hurd.)

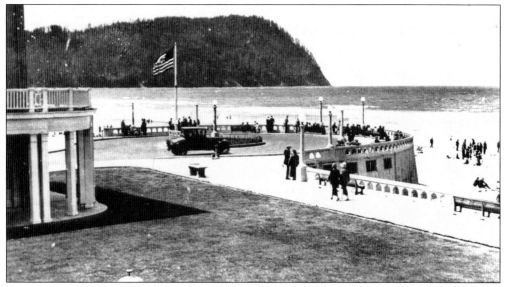

Eventually a flagpole was added at the center of the turnaround. Tillamook Head can be seen in the distance. Tillamook Head, a promontory named for the Tillamook Indians, is at the southern end of the city. A hiking trail leads to the top of Tillamook Head to a point 1,130 feet above sea level, where the Lewis and Clark party viewed the Pacific Ocean. (Courtesy of the Seaside Historical Society.)

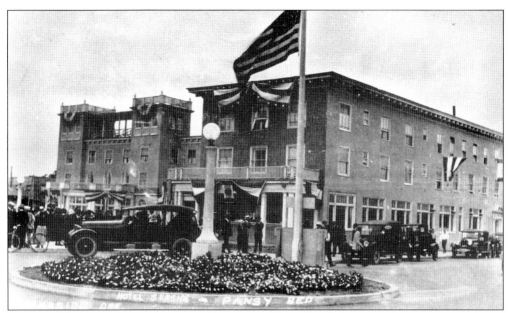

Begonias from the greenhouses at the Tides Motel, 2316 Beach Drive, were often planted in the garden at the center of the turnaround. The Begonia Gardens were noted as a tourist attraction in the city directories of the era. Pansies were also planted there in the spring. (Courtesy of the Seaside Historical Society.)

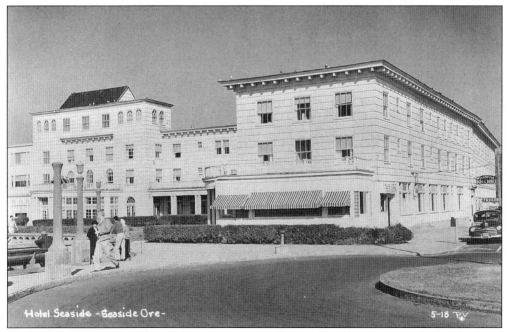

Drinking fountains were placed along the promenade as well as the turnaround. One drinking fountain can be seen to the left of center. (Courtesy of the Seaside Historical Society.)

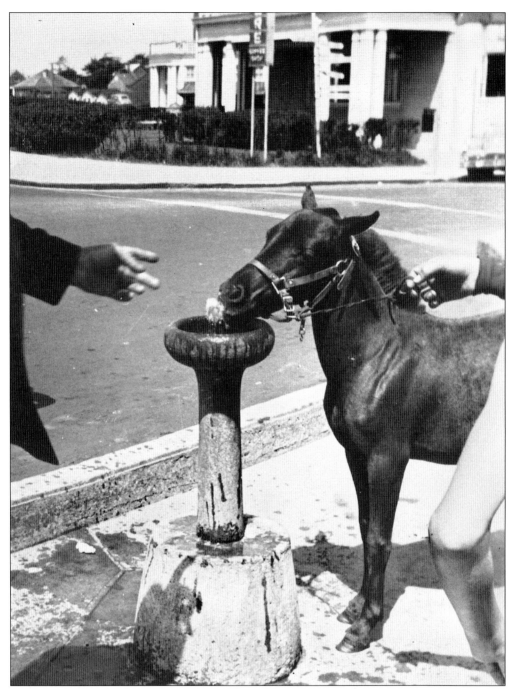

Here a small horse drinks from a water fountain at the turnaround. The Seaside Hotel is in the background. A drinking fountain at Third Avenue and Prom was donated by Charles T. Early. (Courtesy of Edna Marie Thorn.)

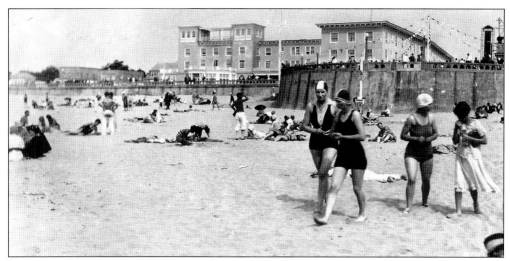

The J. H. Tillman Company began work on the seawall in November 1920. The seawall beneath the promenade ranged from 6 to 22 feet high and was 6,400 feet in length. Beachgoers climb down a series of stairs from the promenade to reach the beach. The stairs were placed every 400 feet along the promenade and were 20 feet wide. (Courtesy of the Seaside Historical Society.)

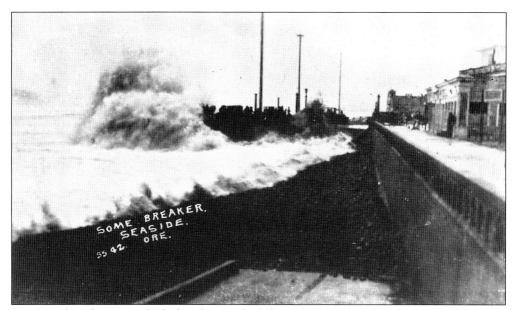

At times, the tides were so high that they reached the stairs, as seen in this photograph. (Courtesy of Edna Marie Thorn.)

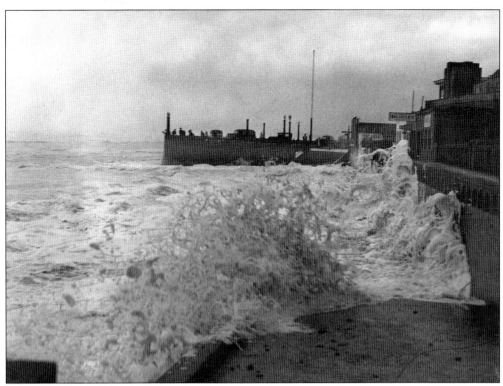

Mother Nature has unleashed her fury many times, but the seawall has stood firm. The following pictures are just an example of some of the storms that have tried to defy the seawall. (Courtesy of the Seaside Historical Society.)

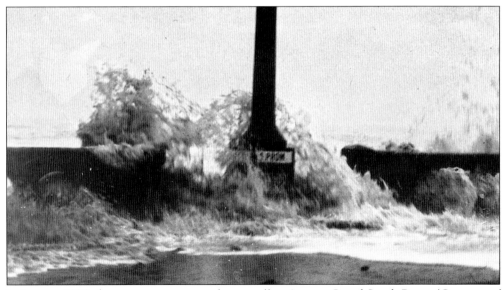

In January 1926, the ocean came across the seawall at Avenue G and South Prom. (Courtesy of Edna Marie Thorn.)

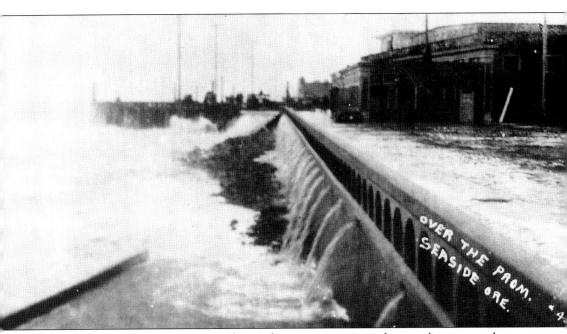

As the water receded at the turnaround near the natatorium, an indoor pool, it appeared as a small waterfall. (Courtesy of Edna Marie Thorn.)

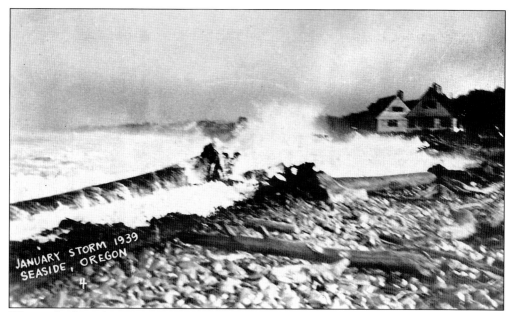
Winter also brought snow as seen in this picture of the area south of the prom during January 1939. (Courtesy of Edna Marie Thorn.)

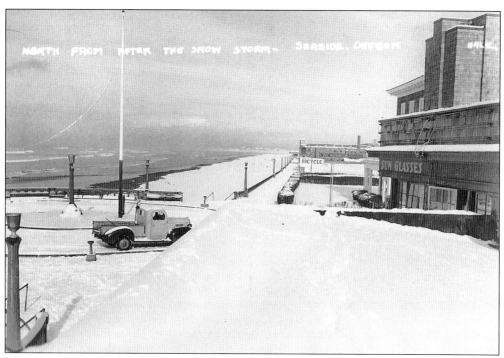
That same storm blanketed the buildings and covered the beach and the turnaround in winter white. This view looks north up the beach from the turnaround. (Courtesy of the Seaside Historical Society.)

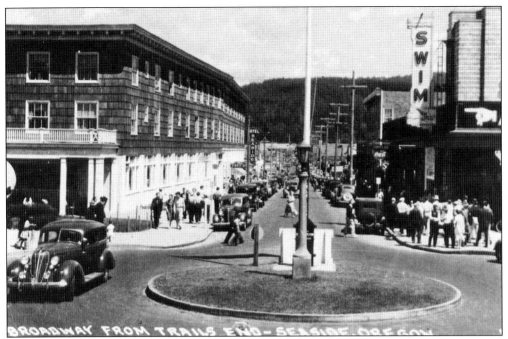
Warm weather once again brought the tourists. At right in this photograph, the word "swim" locates the natatorium, built at the turnaround in 1912. (Courtesy of the Seaside Historical Society.)

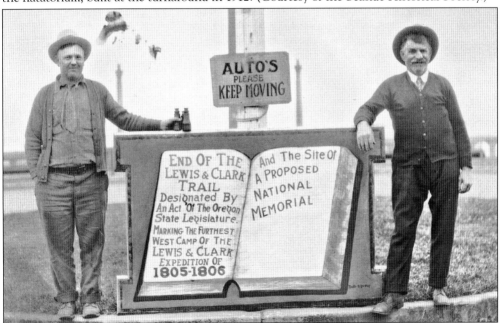
In February 1923, an act of the legislature designated Broadway Drive as the end of the Lewis and Clark trail. The legislation was placed by Rep. Erle N. Hurd as State House Bill No. 133 and had already been passed through the Oregon Senate by the time it was sent to the governor. Tommy Ruthrauff created a sign to commemorate the act, and it was placed in front of the flagpole at the turnaround. This 1931 photograph shows Bob Burroughs (left) and Sam McCall (right) standing next to the early sign. (Courtesy of Carol Middleton.)

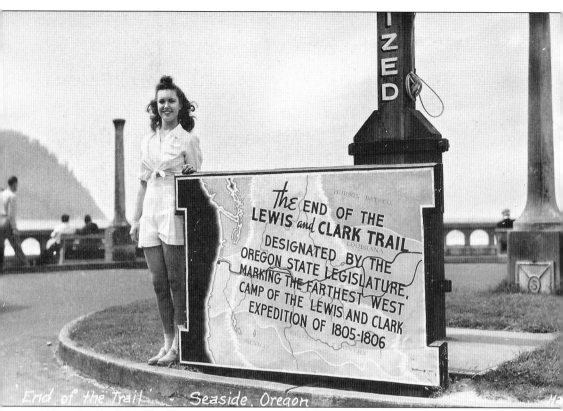

New "End of the Trail" signs were erected at the turnaround, providing a scenic spot for many photographs. The wording on the flagpole reads "Wolmanized." (Courtesy of Edna Marie Thorn.)

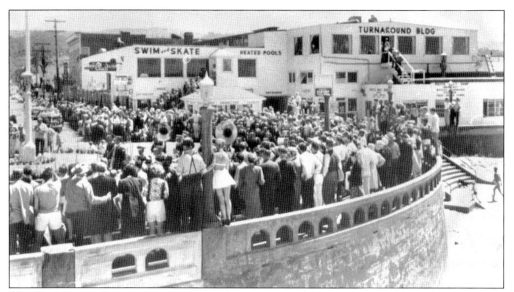

The Seaside parade route often ended at the turnaround. The building holding the natatorium soon included a dance floor and a roller-skating rink. Named the Turnaround Building, it was also the Trails End Club. (Courtesy of the Seaside Historical Society.)

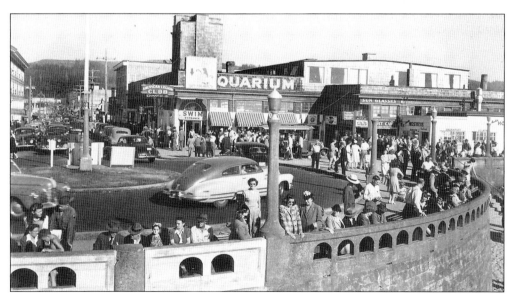

The American Legion post in Seaside, organized on February 23, 1921, was also located in the same building at the turnaround. If the beach was too chilly, the natatorium offered a warm place to swim and still be in saltwater. From December 1926 to April 1927, a group attempted to raise silver salmon in the building's pools. This natatorium was purchased by John E. Oates in 1923. (Courtesy of Edna Marie Thorn.)

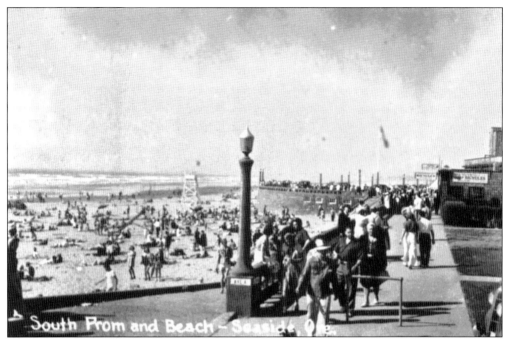

Looking from south of the turnaround, the lifeguard station is on the left. An observation tower for the lifeguard station was built in 1923. The new tower and trouble semaphores made it the "best guarded" beach on the Pacific coast. (Courtesy of the Seaside Historical Society.)

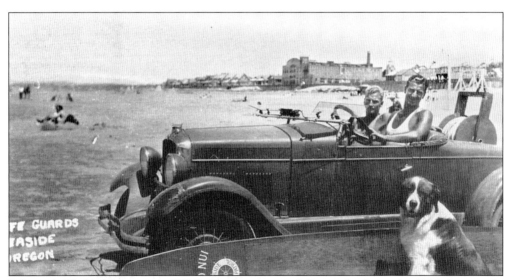

Lifeguards Clarke Thompson and Wally Hug hang out with Bruno the dog in this 1936 photograph. Sections of the beach were, and continue to be, a designated highway. Often the lifeguards would patrol the beach in their vehicles. Bruno assisted with surf rescues. (Courtesy of the Seaside Historical Society.)

Lifeguards became a common sight on the beach and rescued many people from the ever-changing surf. This unidentified group is pictured here in 1939. Wallace Hug, Jim Reed, H. P. Terwilliger, Luke Littlejohn, Bob Hodges, and Ed Palmrose were just a few of the lifeguards at Seaside. (Courtesy of Edna Marie Thorn.)

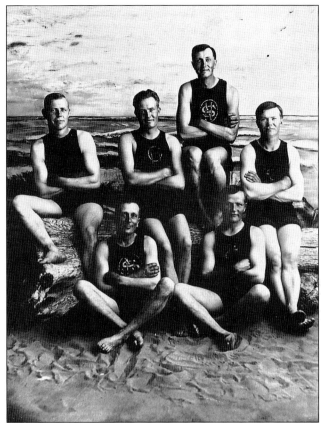

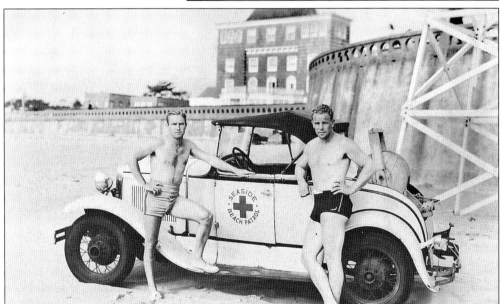

Some of the lifeguards were local young men, and some just came to spend their summers in Seaside. The lifeguards also used a vehicle to patrol the beach. Ed Palmrose, right, went on to become a local physician. (Courtesy of Edna Marie Thorn.)

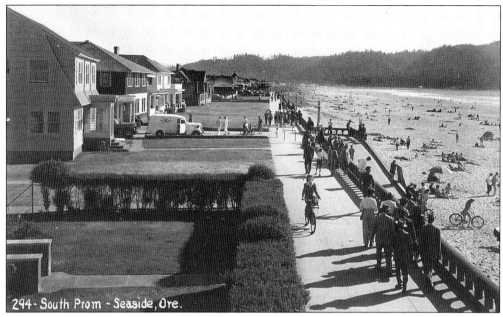

Looking south, many homes were built along the promenade. Concrete ramps provided access to the beach at several locations. Vehicles were not allowed on the promenade so access to these homes was from Beach Drive, which ran about two blocks behind houses. (Courtesy of Edna Marie Thorn.)

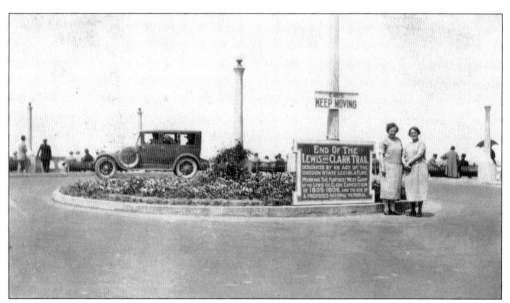

Marjorie White and Irene Raw stand next to one of the many "End of the Trail" signs that were placed in Seaside at the turnaround. (Courtesy of Lester Raw II.)

Two
BUSINESS AS USUAL

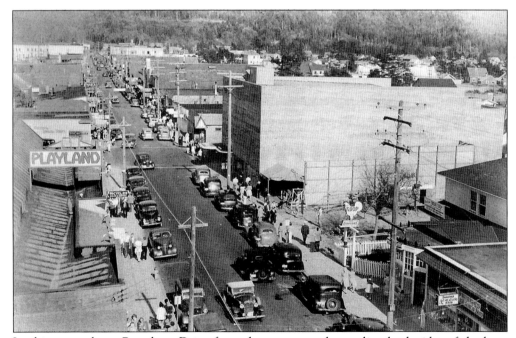

Looking east down Broadway Drive from the turnaround, cars line both sides of the busy thoroughfare. In the foreground is the Chicken Koop Restaurant and Playland, both gathering places for locals and tourists alike. (Courtesy of the Seaside Historical Society.)

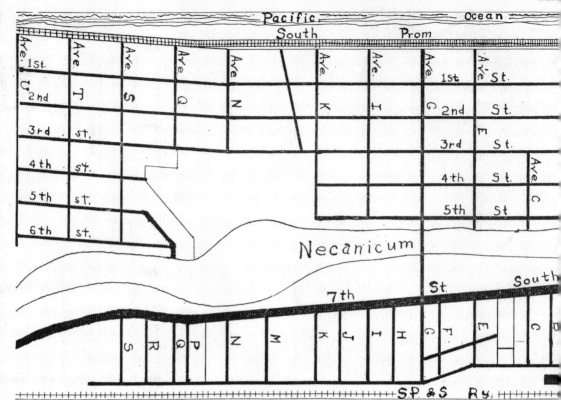

This is a map from the Residence Directory of Clatsop Beaches 1935. Charles B. Compton was the publisher. Maps such as this were published in the city directories much the same as they appear in the current telephone books. The Clatsop Beaches included the beach areas of Clatsop

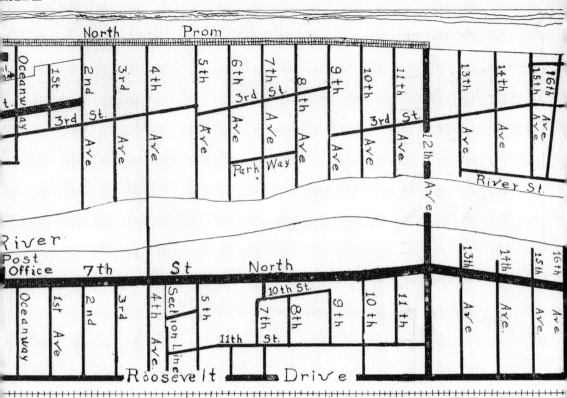

finding residence locations, and to aid local residents in showing visitors the locations they seek.
ets north and south, in a general way.
ded herein. Avenue residence numbers less than 500 are west of Necanicum river, and street
h from Broadway.

County from the Columbia River on the north, south to Tillamook Head. (Courtesy of the Seaside Historical Society.)

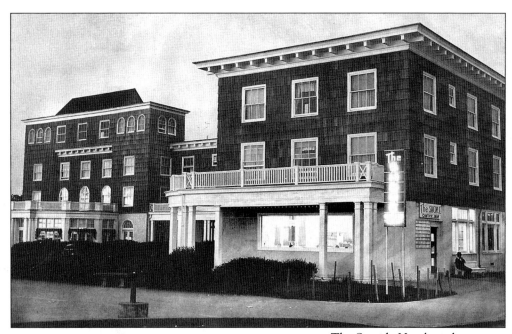

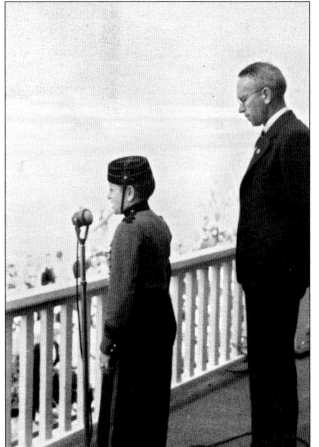

The Seaside Hotel on the northeast corner of the turnaround was often the location for high school proms. Note the drinking fountain in front and the sign for the Shore Coffee Shop. Western Union was located at the hotel beginning in June 1921. Called the Seaside Hotel from 1920, the name was changed to the Seasider Hotel in 1959. It closed in 1983. (Courtesy of Edna Marie Thorn.)

Many residents mentioned the "Philip Morris" man who used to stand on the balcony of the hotel and make announcements. A radio announcement for Philip Morris cigarettes showed a young man, dressed like the boy in this picture, who would say, "Call for Philip Morris." This would then be followed by civic announcements. The Seaside Hotel replicated the costume and form of public address. Here apparently someone was about to receive the key to the city. (Courtesy of Edna Marie Thorn.)

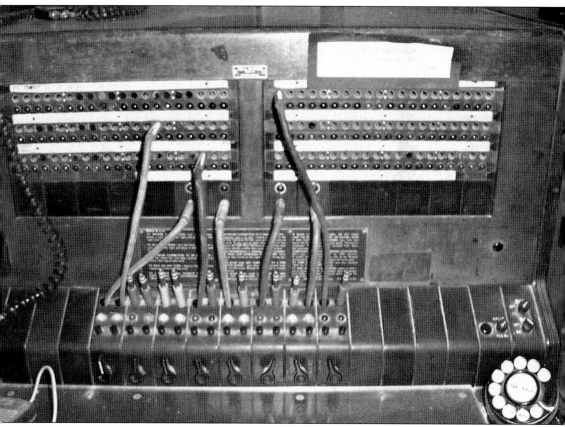

This telephone switchboard was located inside the Seaside Hotel. It is now at the Seaside Museum in an exhibit titled 100 North Prom.

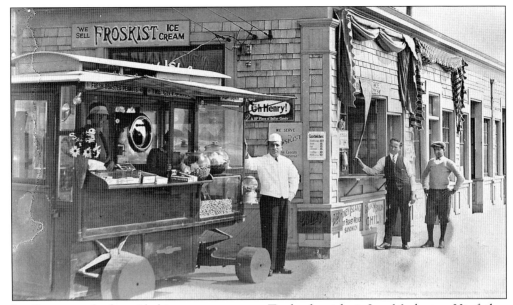

Jay Bangs stands alongside his popcorn wagon. To the far right is Leo Marlantes. His father owned a grocery store on Broadway Drive that burned in the Hippodrome fire in September 1923. (Courtesy of Edna Marie Thorn.)

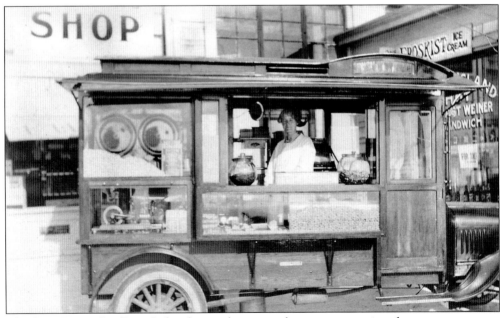

Charlotte Bangs, Jay Bangs's daughter-in-law, was often seen operating the popcorn wagon. (Courtesy of Edna Marie Thorn.)

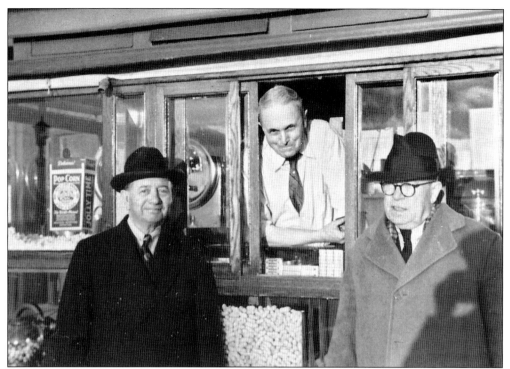

John E. Oates, owner of the Oates Baths, and William Montag, owner of Montag's Photo Shop, stand with Jay Bangs at his popcorn wagon. (Courtesy of Edna Marie Thorn.)

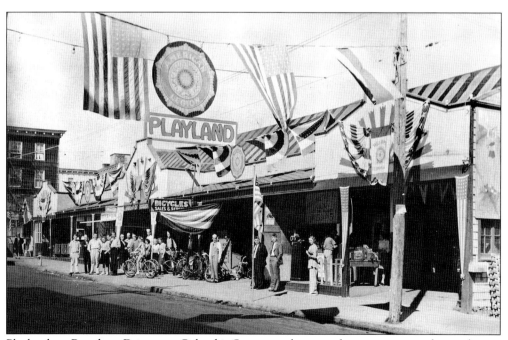

Playland, on Broadway Drive near Columbia Street, was home to the merry-go-round, crazy house, and numerous other amusements. (Courtesy of Edna Marie Thorn.)

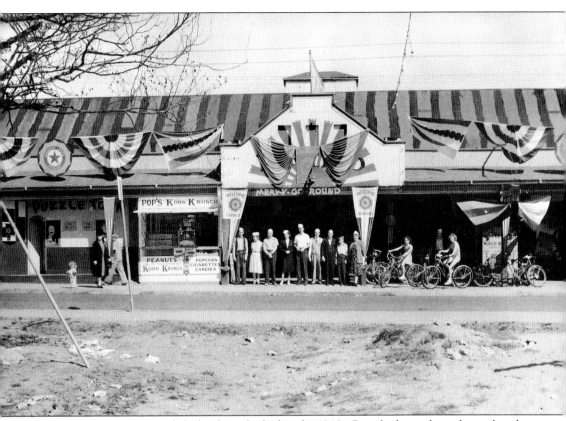

This is another view of Playland as it looked in the 1940s. Bicycles have always been abundant on the Seaside streets, and rental shops provided the tourists with this efficient mode of transportation, which was extremely useful during gas rationing. (Courtesy of Edna Marie Thorn.)

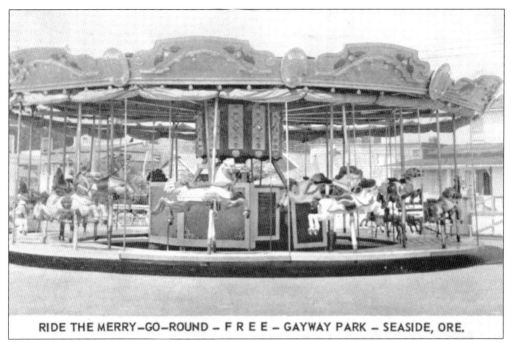

RIDE THE MERRY-GO-ROUND — F R E E — GAYWAY PARK — SEASIDE, ORE.

The merry-go-round was moved from inside Playland to Gayway Amusement Park. Located at 115 Broadway Drive, the amusement park also had a Ferris wheel, midget autos, boats, and other attractions. (Courtesy of the Seaside Historical Society.)

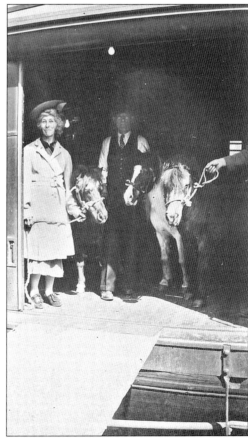

Lisa Wallace had donkey and pony rides on the beach. Here she stands at the door of the stable with two of her steeds. (Courtesy of Edna Marie Thorn.)

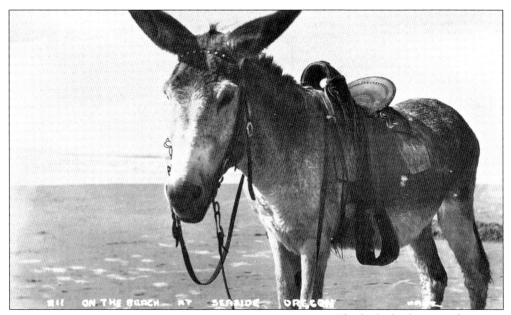

The little donkey was always a big hit for adults and children alike. (Courtesy of Edna Marie Thorn.)

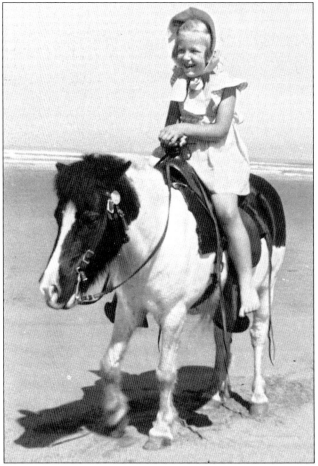

This young, unidentified visitor is saddled up for her pony ride on the beach. (Courtesy of Edna Marie Thorn.)

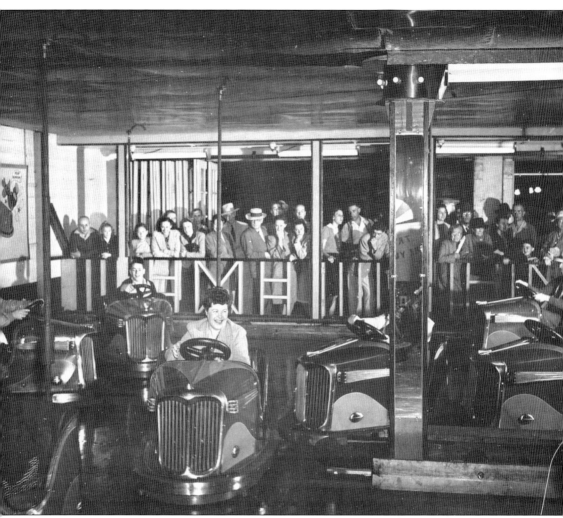

The bumper cars, owned by Larry Johanns, and Russell's Variety Store, a five-and-dime, were both located on Broadway Drive. (Courtesy of Edna Marie Thorn.)

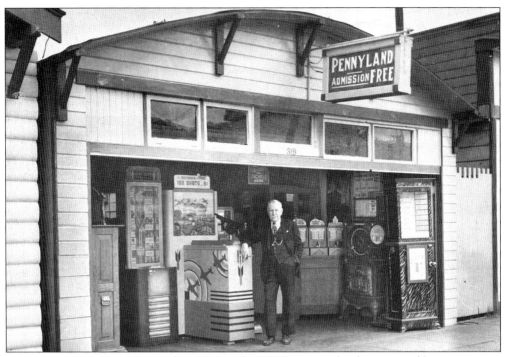

Located at 319 Broadway Drive, Pennyland was owned by August Krause. Playland, and later Funland, located at 201 Broadway Drive, were owned by Vern Raw. All three locations had a variety of machines that offered movies, flashing lights, and other entertainment for a penny or a nickel. (Courtesy of Edna Marie Thorn.)

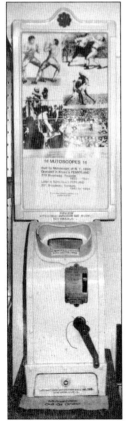

One such machine was the Mutoscope, pictured here, where the viewer could watch a movie for a penny. This one is at the Seaside Museum; other machines from the businesses are at Marsh's Free Museum in Long Beach, Washington.

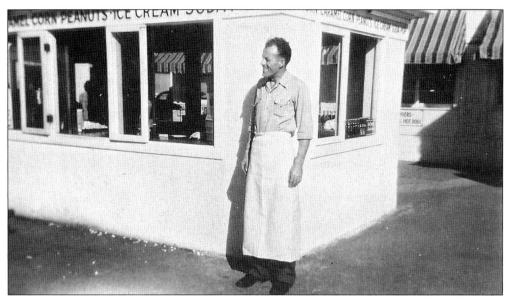

"Pop" Waters stands outside his shop that sold popcorn, peanuts, and ice cream. Located on Broadway Drive, Pop's small shop is now gone. (Courtesy of Edna Marie Thorn.)

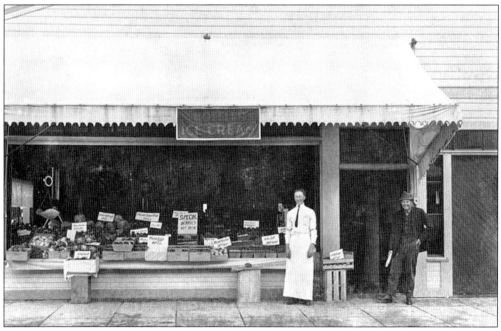

There were several grocery stores along Broadway Drive. This one possibly belonged to Cam Larson and was located just west of the drugstore on the north side of the street. (Courtesy of Jean TerHar.)

Following the fire in the Gilbert Building, which also burned the Safeway store, a new Safeway was built at the southwest corner of Holladay Drive and First Avenue. (Courtesy of Edna Marie Thorn.)

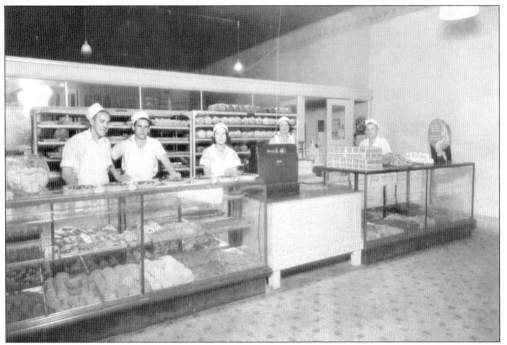

Harrison's Bakery, also on Broadway Drive, baked giant cookies and wonderful bread. For many years, the old sign from the natatorium hung in their store. The bakery closed at the end of 2006. On the far left is James Elmer Sophy. (Courtesy of the Seaside Historical Society.)

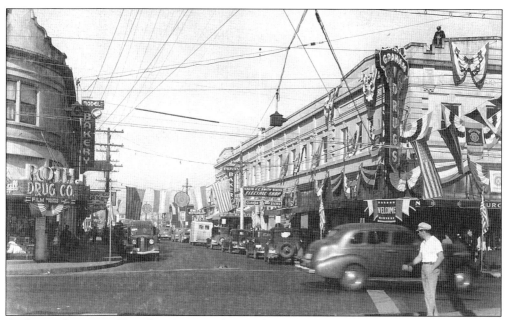

At the north corner of Broadway Drive and Seventh Street was Graham Drugs. Roth Drug was on the south corner. The Gilbert Building on the north corner was the scene of the fire in February 1939. Following the fire, the *Astoria Budget* noted that "Seaside imbibers of alcoholic beverages will have to go dry for a time or else go to other communities, for their supply at the only state liquor agency was in the Graham Drug Store." (Courtesy of Edna Marie Thorn.)

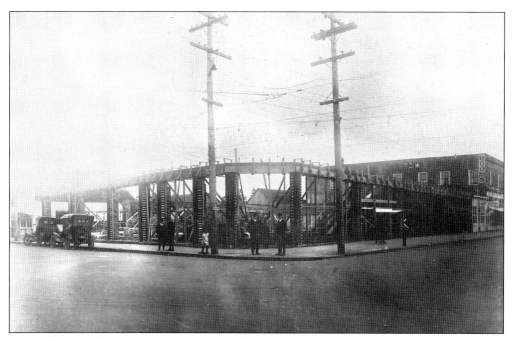

Pictured here while under construction is the future home of J. C. Penney at the corner of Seventh Street and Broadway Drive. This building was later occupied by Wheatley's in 1934. (Courtesy of Edna Marie Thorn.)

Looking south on Seventh Street, now Holladay Drive, not many businesses have been built. (Courtesy of the Seaside Historical Society.)

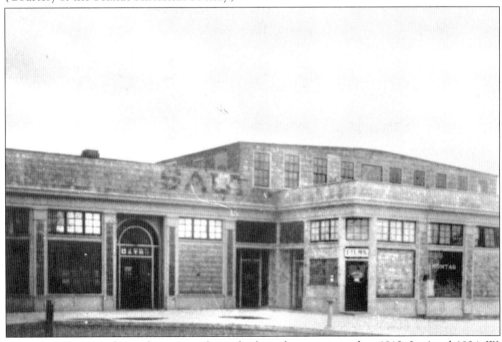

A natatorium, an indoor saltwater pool, was built at the turnaround in 1912. In April 1924, W. A. Viggers announced plans, along with W. F. Jones, to build a natatorium on the southeast side of the turnaround. Later the spot became known as the Turnaround Building and was the site of dances and roller-skating. Built at a cost of $35,000, it was demolished in 1967. (Courtesy of the Seaside Historical Society.)

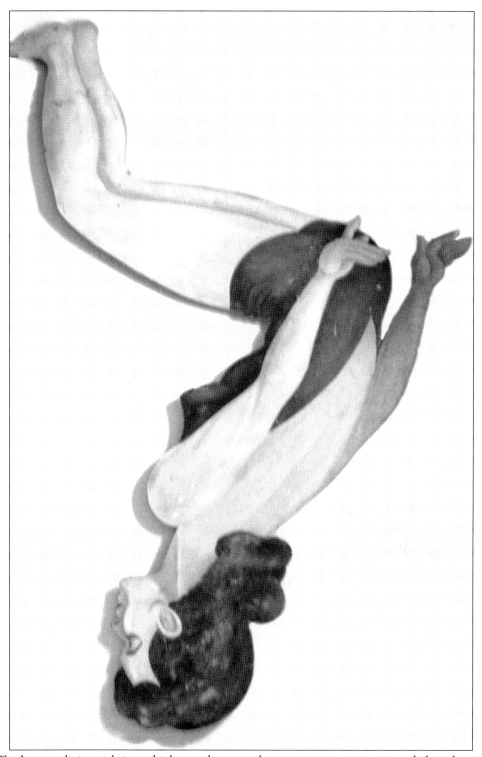

The Jantzen diving girl sign, which once hung on the natatorium, now is suspended on the wall at the Coffee Shop at Seaside on Broadway Drive.

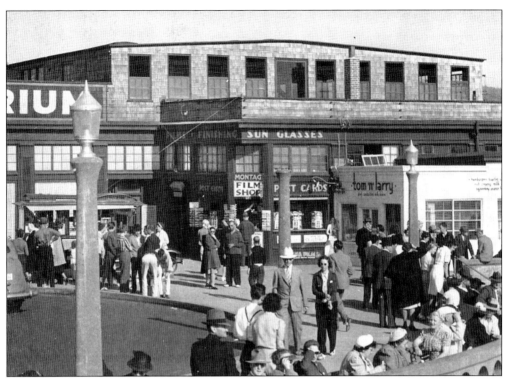

Many other small businesses soon appeared on the turnaround. Montag's Film Shop and Tom and Larry's, which sold candy and ice cream, were on the south side. (Courtesy of the Seaside Historical Society.)

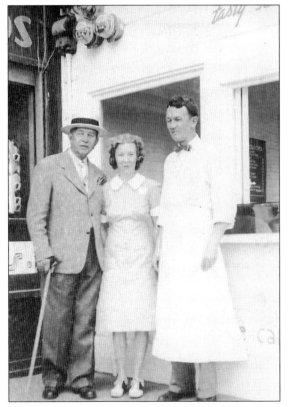

Pictured here are, from left to right, William Montag of Montag Film Shop and Charlotte and Tom Harris of Tom and Larry's. Larry Hillaire, the other owner of Tom and Larry's, is not pictured. (Courtesy of Edna Marie Thorn.)

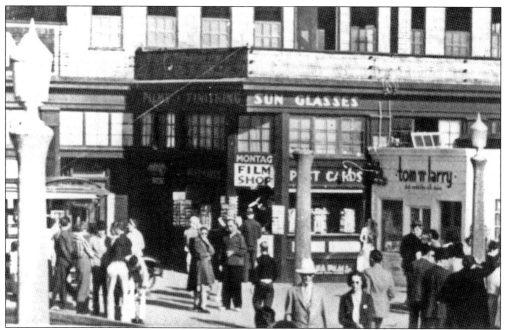

William Montag took pictures of many of the visitors to Seaside, as well as the local residents. The historical society has many of these photographs and numerous glass plates, which have yet to be identified. In 1940, Montag's Film Shop was sold to Leslie Hale. (Courtesy of Edna Marie Thorn.)

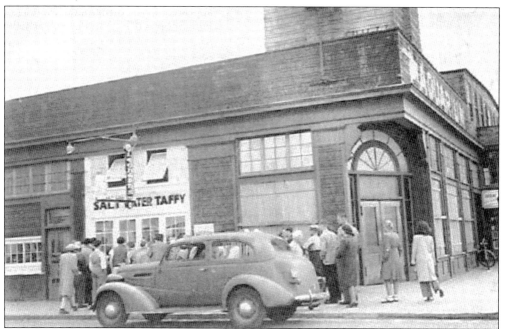

Just down from the natatorium was "Tiny" Leonard's Salt Water Taffy store. "Tiny" was Elmer Ellsworth Leonard, a retired pitcher for the Philadelphia Athletics and an Oakland, California, team. He was in *Ripley's Believe it or Not!* for pitching "74 consecutive innings in 1914 without giving a base on balls" while on a team in Ballard, Washington. (Courtesy of Edna Marie Thorn.)

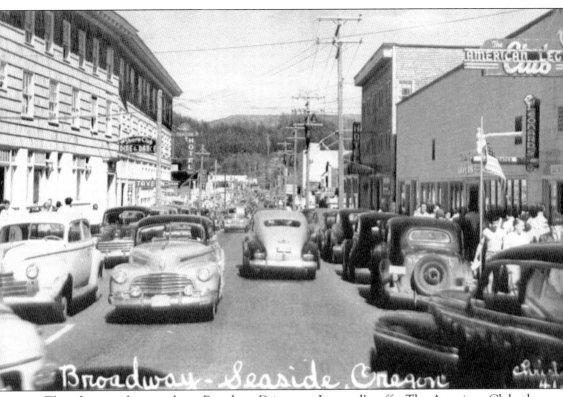

This photograph scans down Broadway Drive past Leonard's taffy. The American Club, the Shore Club, and several hotels are visible. Seaside offered many places to eat, sleep, and play for tourists. The sign on Leonard's taffy was made by Tommy Ruthrauff. (Courtesy of the Seaside Historical Society.)

Pictured here is "Tiny" Leonard with his son Bud, Phyllis Mathisen, and an unidentified woman. (Courtesy of Edna Marie Thorn.)

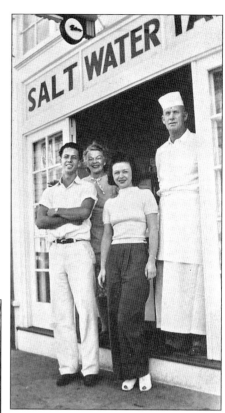

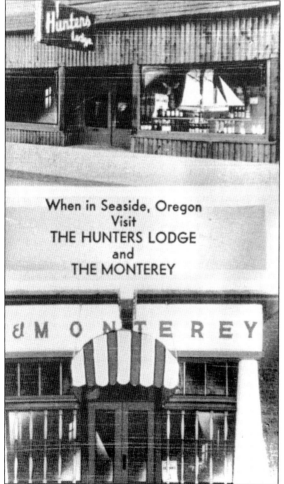

The Hunters Lodge, later the Monterey Supper Club at 405 Broadway Drive, was owned by Lester Raw. During the 1940s, the Monterey Club was also used as a teenage club. (Courtesy of the Seaside Historical Society.)

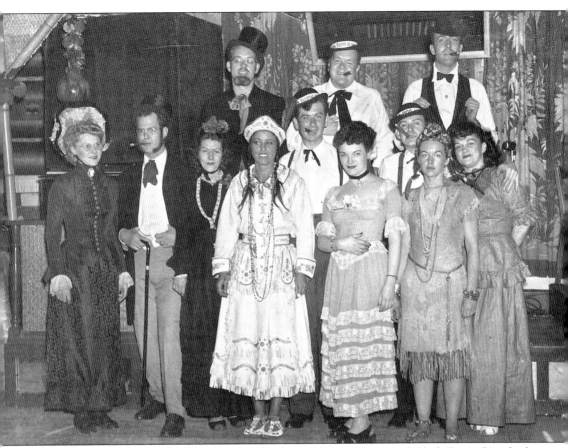

The Monterey Supper Club working staff is dressed for the Lewis and Clark Festival in the late 1940s. Pictured here are Lester Raw Sr., with top hat and beard; Margaret Carter at far left; and Marjorie White (Tubby Morgan) in Native American dress. (Courtesy of Lester Raw II.)

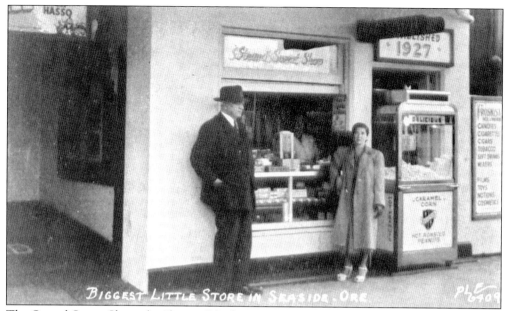

The Strand Sweet Shop, the "biggest" little store in Seaside, was located outside the Strand Theater. Here "Dad" Callahan and Leone B. McMahon, the proprietor of the shop, are standing in front of the store. Leone McMahon was the step-daughter of B. J. Callahan, owner of the Strand Theater. (Courtesy of the Seaside Historical Society.)

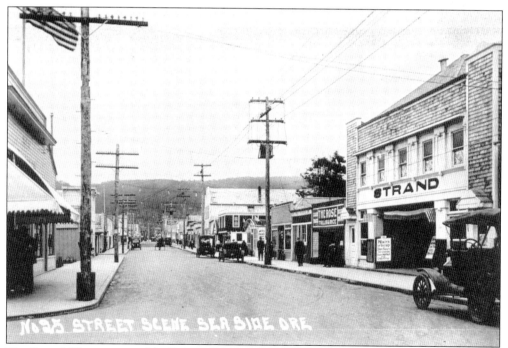

The Strand Theater, owned by B. J. Callahan, had a pipe organ. Our Savior's Lutheran Church met at the theater before its own church building was constructed. There was also a wrestling match put on at the theater in the 1930s. Across the street on the corner is the Bungalow Dance Hall. (Courtesy of the Seaside Historical Society.)

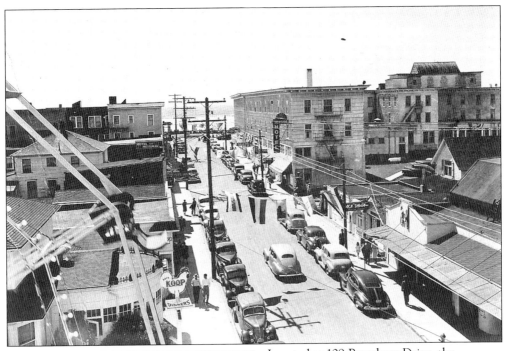

Located at 109 Broadway Drive, the Chicken Koop is seen through the ribs of the Ferris wheel on the lower left. The Chicken Koop was known for their good service and good food. Chicken dishes were a specialty. (Courtesy of Edna Marie Thorn.)

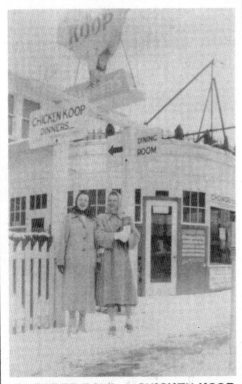

The Chicken Koop was a popular eating establishment. Following a fire, the owners rebuilt the restaurant on Downing Street. Pictured are Louise Cope and her daughter Linda Cope. (Courtesy of Edna Marie Thorn.)

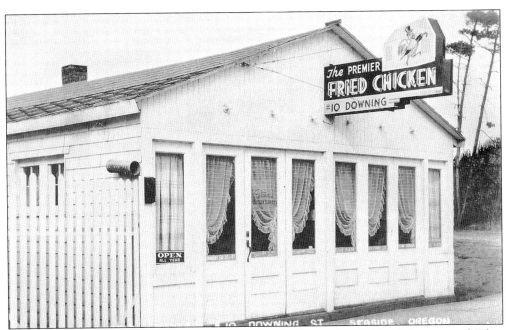
Seen here is the Chicken Koop after it was rebuilt in the 1940s. (Courtesy of Edna Marie Thorn.)

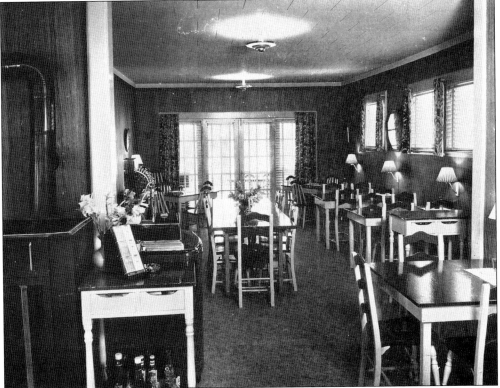
This view shows the interior of the Chicken Koop on Downing Street. (Courtesy of Edna Marie Thorn.)

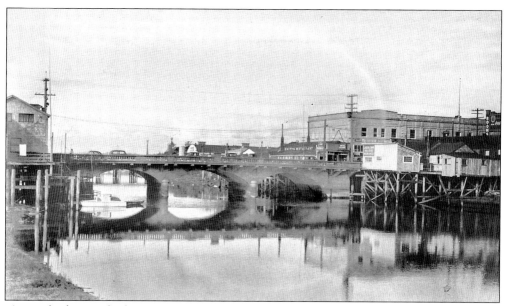

A new bridge was built across the Necanicum River on Broadway Drive in December 1923. (Courtesy of Edna Marie Thorn.)

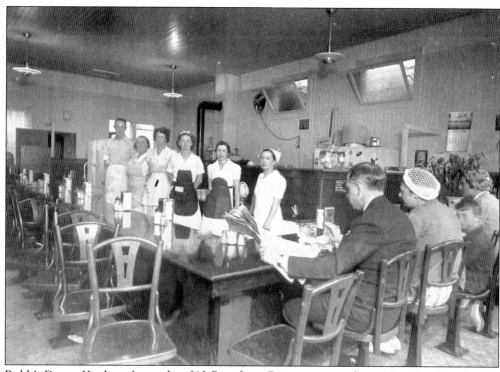

Robb's Donut Kitchen, located at 310 Broadway Drive, was another gathering place for the locals. Pictured are, from left to right, Luther ?, Blanch Wilson, ? Manett, Lena Beaver, Evelyn Wright, Tilley Langman, Gene Legg, and three unidentified individuals. (Courtesy of the Seaside Historical Society.)

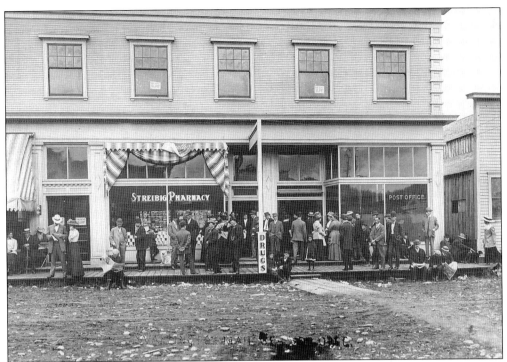

Before the establishment of a separate building for the U.S. post office, it was housed in several locations. Here Seasiders await mail delivery outside the post office when it was next door to the Streibig Pharmacy. E. N. Hurd was postmaster in 1925. (Courtesy of the Seaside Historical Society.)

Beginning in 1914, city hall was located in this building on Broadway Drive. The fire department was next door. (Courtesy of the Seaside Historical Society.)

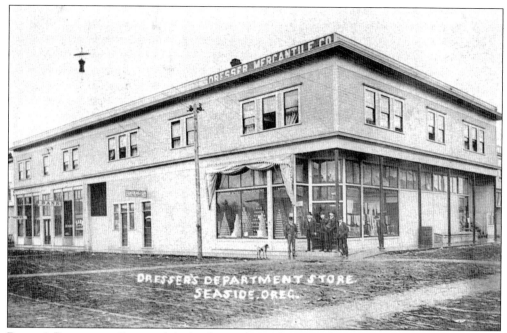

Dresser's Department Store and the bank were located on Broadway Drive east of Seventh Street. (Courtesy of the Seaside Historical Society; photograph donated by Mynette Mathisen.)

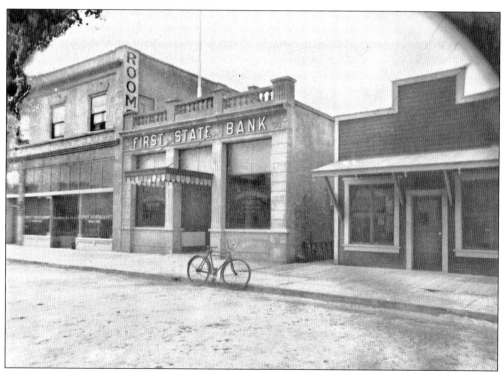

The First State Bank was located at 734 Broadway Drive. The bank opened between 1910 and 1915 and closed for a second time in 1927. It was also known as Clatsop County Bank. Steps were taken in April 1928 to charter a new bank. (Courtesy of the Seaside Historical Society.)

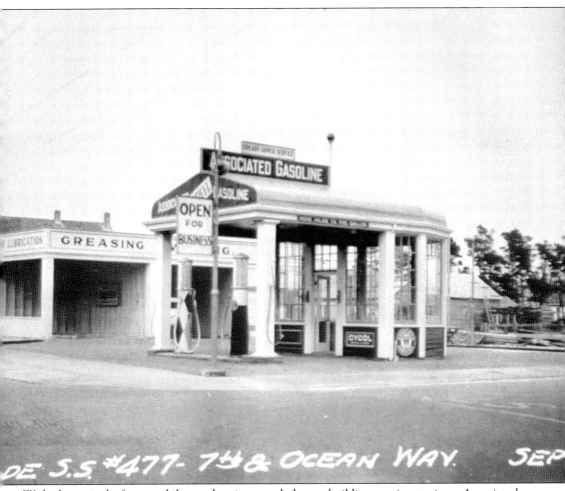

With the arrival of automobiles to the city, people began building service stations. Associated Gasoline was at Seventh Street and Ocean Way. Other service stations included Abbott's Garage on Seventh Street and Hanon Smith Garage, which was located at 201 Seventh Street North. Hanon-Smith sold Chandler and Cleveland automobiles on the lower floor of the Knights of Pythias building, now the Masonic Hall. (Courtesy of the Seaside Historical Society.)

Abbott's Garage, located at 120 Seventh Street North at First Avenue, was taken over by Tagg Motor Company Ford; V8s were sold here in 1935 and the Ford Deluxe Phaeton in 1931. Note the tires in the windows of the garage. (Courtesy of the Seaside Historical Society.)

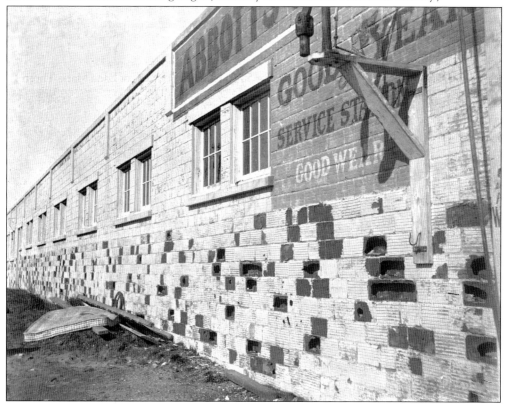

This is a side view of Abbott's Garage. A large sign of a little boy ready for bed proclaimed, "Abbott's—Time to Retire." Frank Parker's Tire Shop was nearby. (Courtesy of the Seaside Historical Society.)

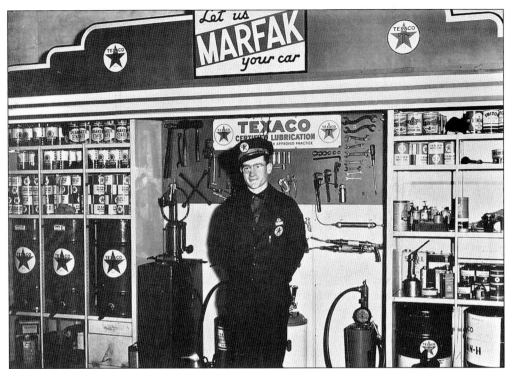

In 1944, a Texaco station was located at Twelfth Avenue and North Holladay Drive. Paddock's Texaco service station opened in 1949 at 615 South Holladay Drive. It is not known which Texaco station is pictured here. In 1920, gasoline was selling for 50¢ a gallon. (Courtesy of Edna Marie Thorn.)

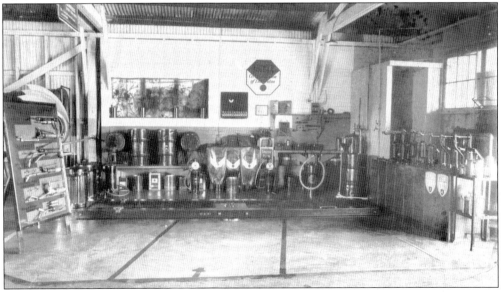

The interiors of service stations, as seen here, have changed a bit in both appearance and equipment. Many automobile dealerships were established in the city. Laighton-Callahan Motor Company, Inc., at 38 North Seventh Street, sold Hudson-Essex autos and later added Whippet and Willys Knight vehicles. Chevrolets were sold by the C. A. Groat Motor Company in 1935. (Courtesy of the Seaside Historical Society.)

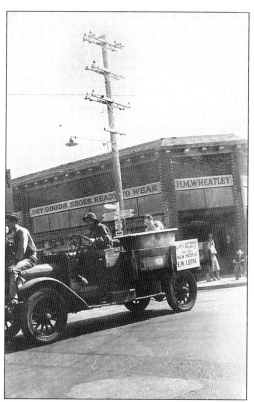

E. W. Leppa owned a plumbing supply store at 545 Broadway Drive. An advertisement for the store is seen on an automobile passing in front of H. M. Wheatley's store. (Courtesy of Frank Stewart.)

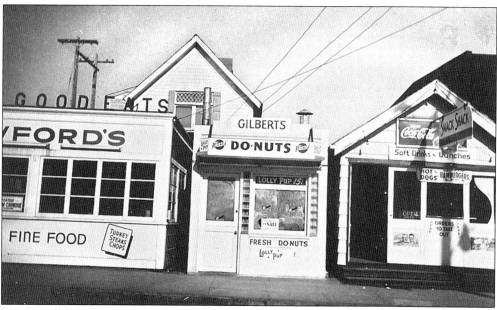

Many small businesses opened throughout the downtown area. Pictured here are Gilbert's Donuts and two other food concessions. Also on Broadway Drive was Poole's Kandy Kitchen, later purchased by the Phillips family in 1939. Ed Poole built a new bowling alley in 1924. The charge was "15 cents per line for 10 frames." The White Spot on Broadway Drive, owned by Helen Davis and her husband, sold hamburgers for 5¢. (Courtesy of Edna Marie Thorn.)

Harold's was located at 323 Broadway Drive from 1938 to 1941. His window advertises "golden brown toasted sandwiches." (Courtesy of the Seaside Historical Society.)

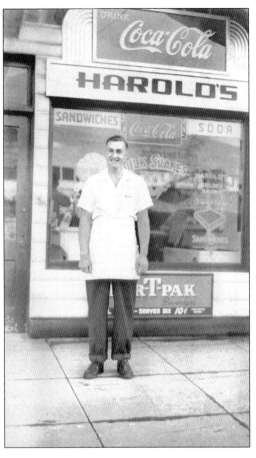

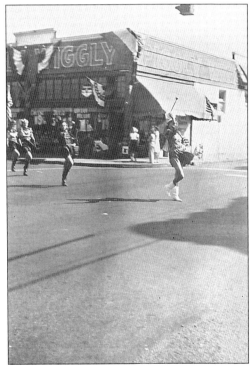

A parade unit passes by the Piggly Wiggly grocery store at the corner of Broadway Drive and North Holladay Drive. (Courtesy of Frank Stewart.)

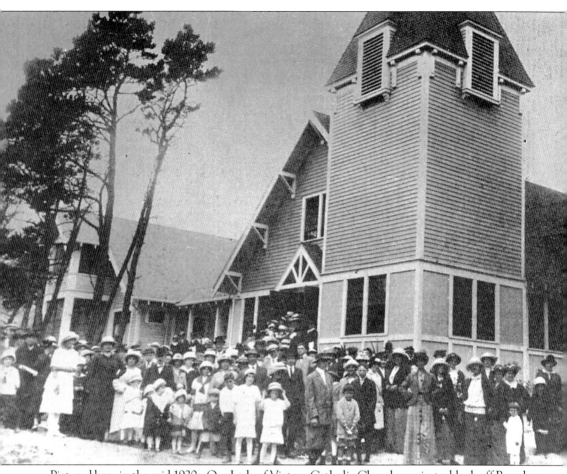
Pictured here in the mid-1920s, Our Lady of Victory Catholic Church was just a block off Broadway Drive at 120 Oceanway and Downing Street. The original church was built in 1900, and although many changes have since occurred, the main portion of the church is still standing. (Courtesy of Leslie Hale.)

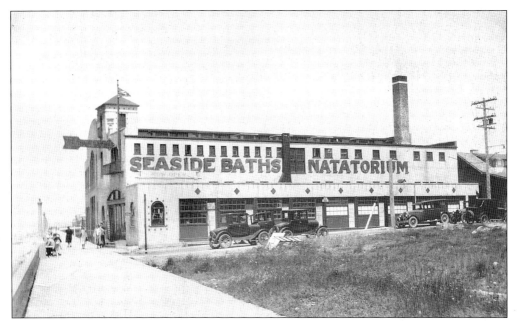

The Seaside Baths Natatorium was built in 1920. It was located between Second and Third Avenues on the Prom. The pool was 50 by 89 feet, kept at a temperature of 70 to 80 degrees, and was filled with saltwater. (Courtesy of Edna Marie Thorn.)

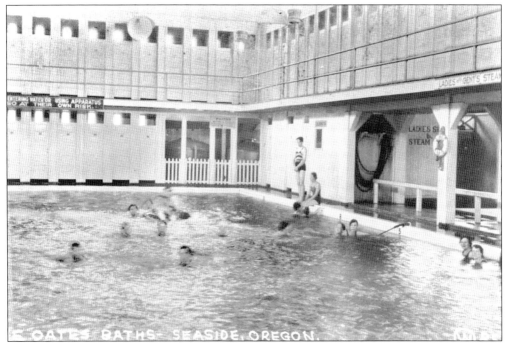

Pictured here is one of the natatorium pools. The sign reads, "Entering the water or using the apparatus . . . do so at their own risk." Steam rooms were also available for "ladies or gents." (Courtesy of Edna Marie Thorn.)

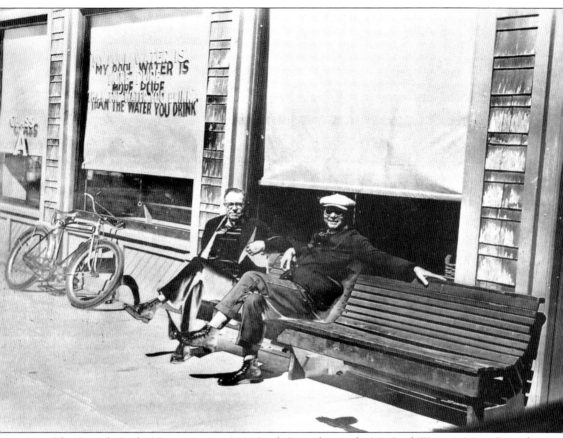

The Seaside Baths Natatorium at 200 North Prom boasted, "My Pool Water is More Pure than the Water you Drink." Seated on the bench are William Montag and John Oates, who built this natatorium. (Courtesy of Edna Marie Thorn.)

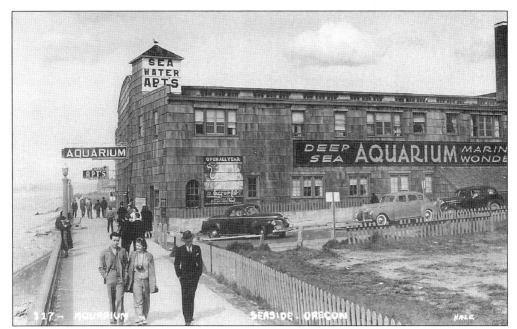

In 1937, the natatorium at 200 North Prom was sold and converted into an aquarium. It is the oldest aquarium on the West Coast. Greta and George Smith, new owners of the aquarium, converted the kiddie pool into a seal pool and also featured an octopus and other local sea creatures. (Courtesy of Edna Marie Thorn.)

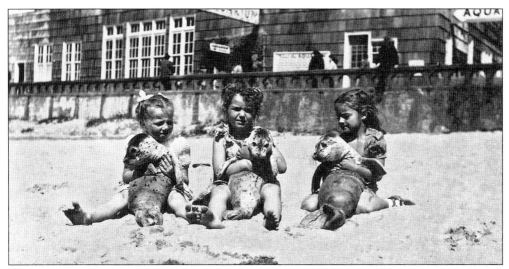

Three young girls hold baby seals from the aquarium on the beach. (Courtesy of Edna Marie Thorn.)

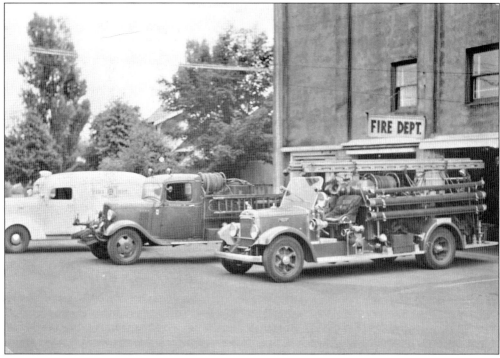

The Seaside Fire Department was kept busy with numerous fires, including the ones previously mentioned. Here the 1938 first-aid car, a 1935 Mack truck, and the 1936 fire truck, built by Seaside Volunteer Fire Department, are parked in front of the firehouse on Broadway Drive near the city hall. The fire department built the fire truck on a 1935 Chevrolet Chassis to accommodate a 1935 Mack triple-combination pumper.

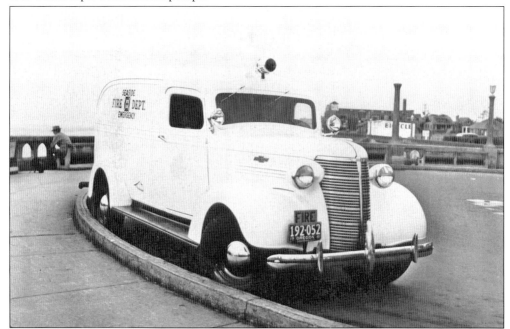

The 1938 first-aid car is parked inside the circle at the turnaround.

Pictured here in 1935 with their new Mack truck are, from left to right, Earl Nichols, Ted Hostika, Bill Layton, "Pop" A. M. Belien, Perry Teevin, Les Bodenhamer, Irving Allen, Chet Gooat (chief), Clarence Owen, Frank Davis, and four unidentified individuals. (Courtesy of the Seaside Historical Society.)

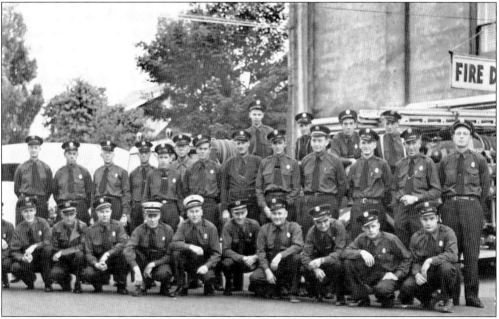

The 1948 fire department members are, from left to right, (first row) Curt Sagner, Rocky Larkins, Clayton Gore, Clyde Layman, Dave Fix, Clarence Owen, Gil Durfeldt, Les Bodenhamer, Cliff Gore, Willard Larson, and ? Littrell; (second row) Chet West, Jack Krieget, Leo Leard, Frank Haikkurd, Hank Galland, Clyde Mason, Harvey Marsh, Paul Nice, Max Frink, George Larfield, Clem Schmidt, Jim Cesto, and Russel Larkins; (third row) Henry Kalfolm, Elmer Easton, Larry Card, and Ed Reilly. (Courtesy of the Seaside Historical Society.)

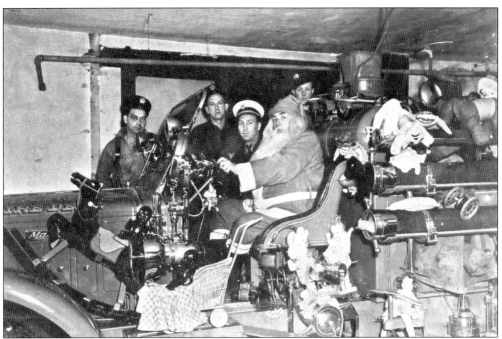
Santa is ready to make deliveries for the Fire Department Toy Drive. From left to right are Leo McFarland, John Kemmerer, Clarence Owen, William Kirk, and Clyde Layman.

Children and fire safety have always been an important part of the community. From left to right are Barry Frink, Easton, Darryl Schmidt, and Lynn Frink.

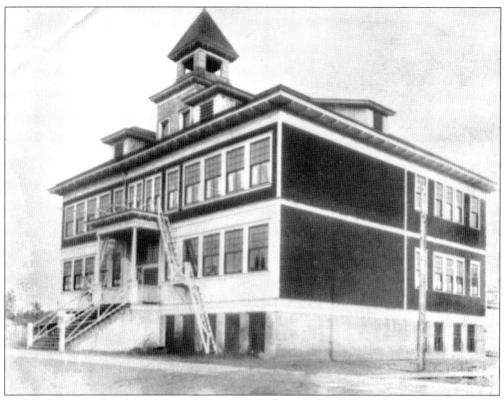
Although not really a business, the school might be considered one of the backbones of the community. The first Central School, pictured here, was replaced by a new building constructed on the grounds next to the old school. (Courtesy of the Seaside Historical Society.)

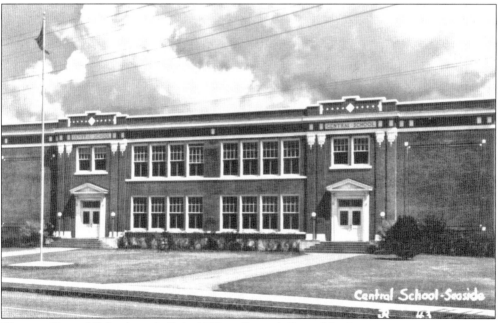
The new Central School was built in 1922 on Seventh Street North.

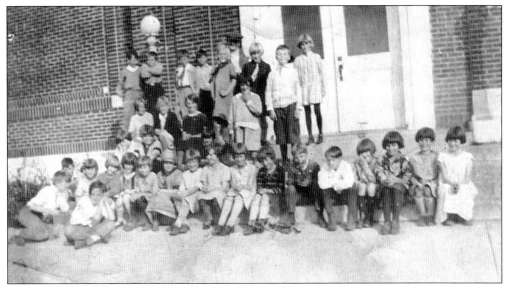

Seen here is a class picture taken at Central School in 1927. Students were in grades one through eight. Samuel Babcock was the principal. When the new school was constructed, the old building was turned into a gym and cafeteria.

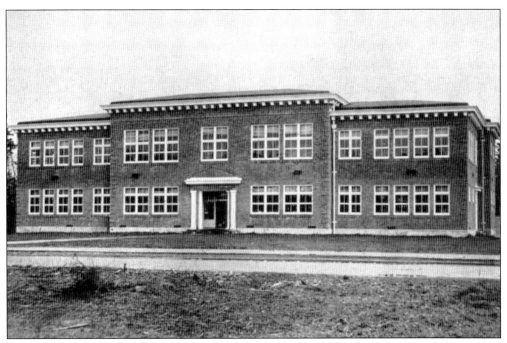

After leaving Central School, students went on to Seaside Union High School, located on Seventh Street, now Holladay Drive. The current high school was built east of the old one in 1959. "Union" was dropped from the name of the new school in 1962. (Courtesy of the Seaside Historical Society.)

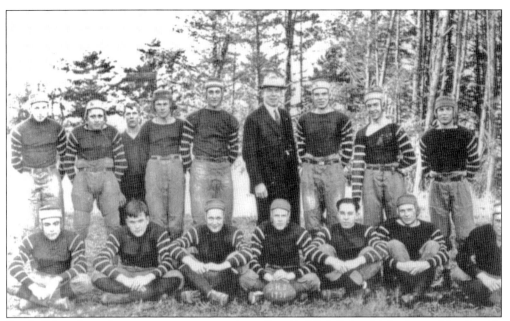

Football has always been an important activity at Seaside High School. Members of the Seaside Union High School team in 1921 are, from left to right, (first row) Raw, Gra'ton, Fulkerson, Lester, Wascher, Culver, and Nelson; (second row) Lukkuren, Blake, F. DeWelt, Owen, Pullen, Van Doren (coach), Spath, Lowe, and A. DeWelt. (Courtesy of Seaside High School.)

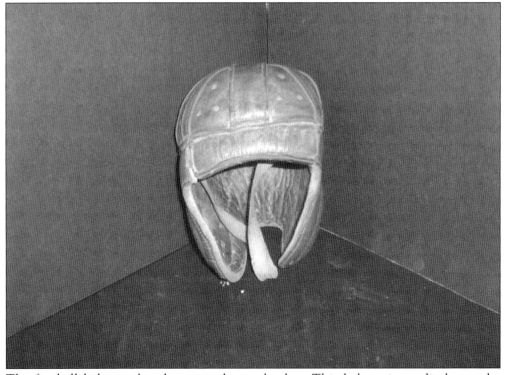

The football helmets the players used were leather. This helmet is on display at the Seaside Museum.

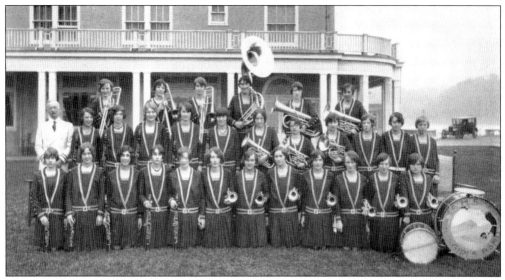

The Seaside High School Girls Band, formed by A. W. Utzinger in 1926, played at many Rose Festivals and other out-of-town events. Utzinger was also in charge of the army band at Fort Stevens. (Courtesy of the Seaside Historical Society.)

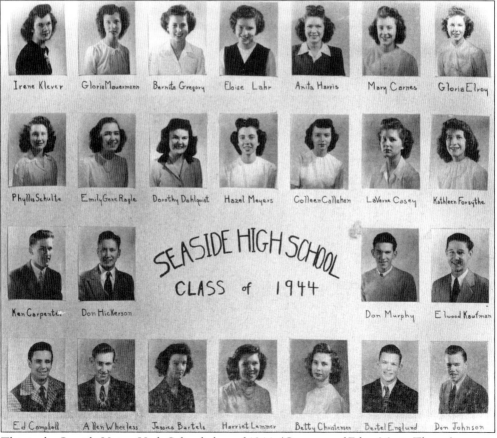

This is the Seaside Union High School class of 1944. (Courtesy of Edna Marie Thorn.)

Three
FUN AND FESTIVITIES

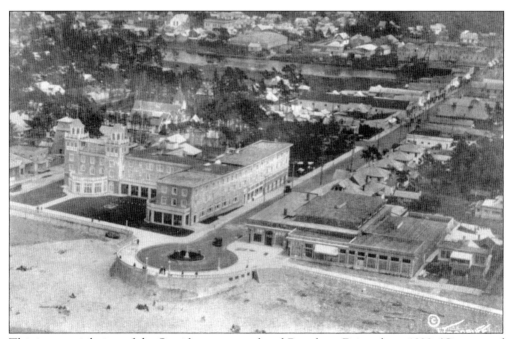

This is an aerial view of the Seaside turnaround and Broadway Drive about 1930. (Courtesy of the Seaside Historical Society.)

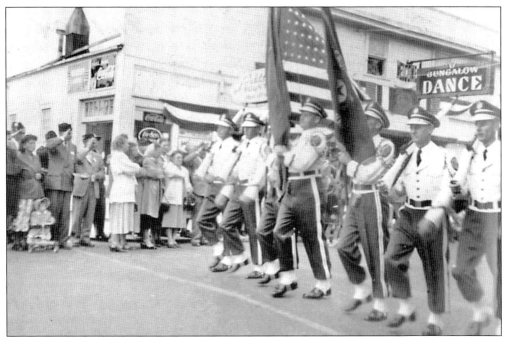

The Fourth of July Parade has always been an exciting event in Seaside. In the background is the Bungalow Dance Hall on Broadway Drive, which opened on June 19, 1920. It was owned by Charles Neimi, M. F. Hardesty, and John Erickson and operated as the Seaside Amusement Company, Inc. Dance halls were quite popular in Seaside. (Courtesy of the Seaside Historical Society.)

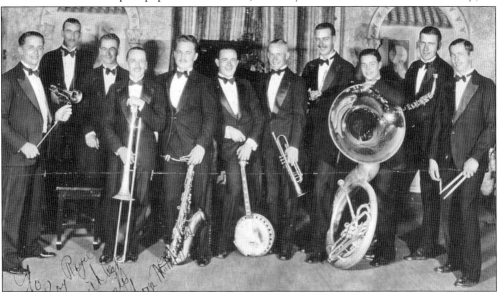

The Bungalow Dance Hall was at the northeast corner of Downing Street and Broadway Drive. Pictures of the dances there are rare, though. Among the name bands that played there were Jimmy Lunceford, Bob Crosby, Phil Harris, Anson Weeks, Buddy Rogers, Duke Ellington, Ted Fio Rito and his Orchestra, Al Thompson and the Tune Tappers, Frankie Carle, Harry James, Glenn Miller, Les Brown, Lionel Hampton, and others. The unidentified band pictured here is ready for the evening's dance. (Courtesy of the Seaside Historical Society.)

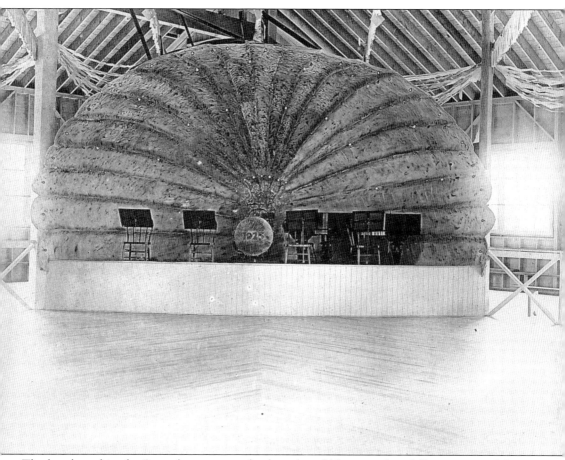

The bandstand in the Bungalow was on wheels and could be moved to different areas of the dance floor, which allowed the band to be seen from various angles. There were big doors and windows on the side of the Bungalow and many of the younger people would stand outside and listen to the music. (Courtesy of Ray Dodge.)

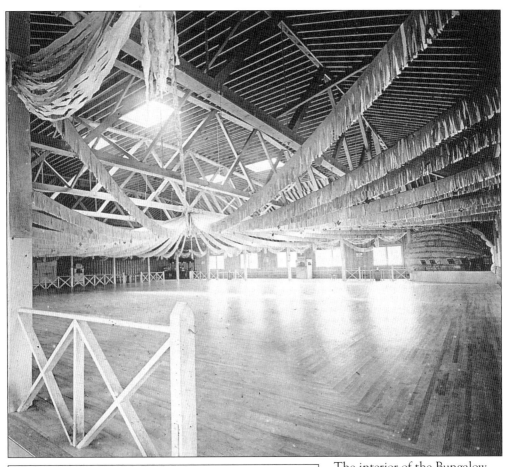

The interior of the Bungalow was decorated with crepe paper streamers for festivities. (Courtesy of Ray Dodge.)

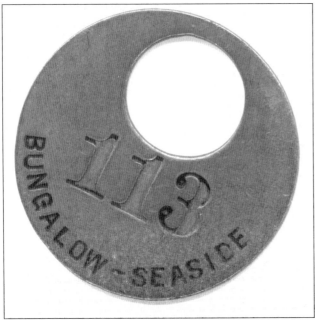

This is a coat check button from the Bungalow. (Courtesy of Mary Cornell.)

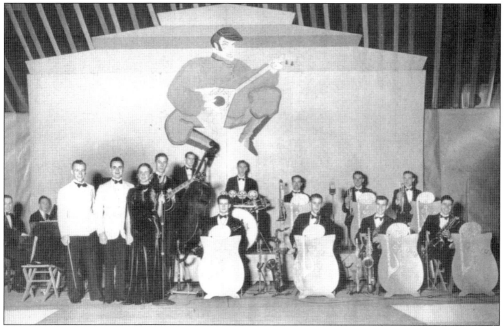

The Gus Meyers band from the University of Oregon prepares for the evening's entertainment. They played at the Bungalow from 1937 through 1938. (Courtesy of Jack Kohl.)

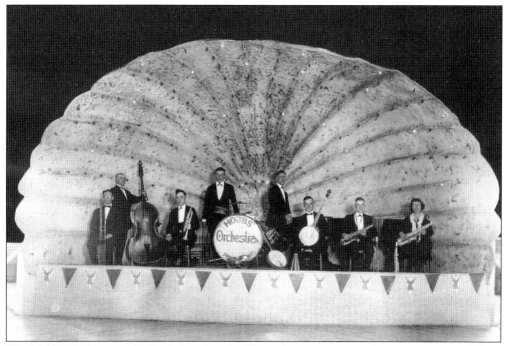

The Hobbs Orchestra, who had played at the Hippodrome prior to its burning, is pictured here at the Bungalow in 1925. (Courtesy of Ray Dodge.)

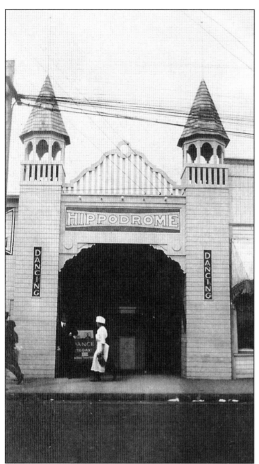

The Hippodrome, a dance hall located along the banks of the Necanicum River, also hosted many renowned bands before it burned in September 1925. It was owned by E. Royce. The grand opening was noted in the *Astoria Budget* on June 23, 1923, with the Hobbs Orchestra from Portland playing. (Courtesy of Ray Dodge.)

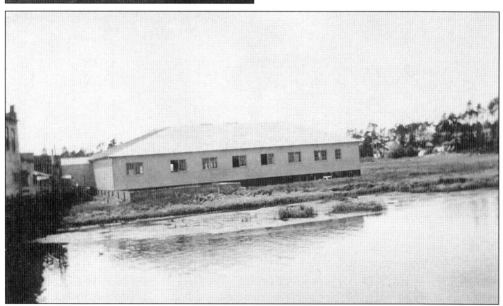

The Hippodrome is pictured from the Necanicum. (Courtesy of Ray Dodge.)

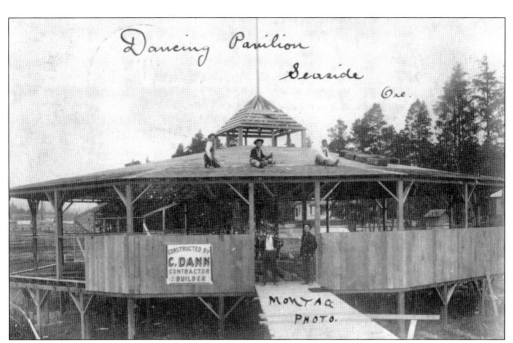
The Octagon Pavilion was another dance site. It was taken down about 1926. (Courtesy of the Seaside Historical Society.)

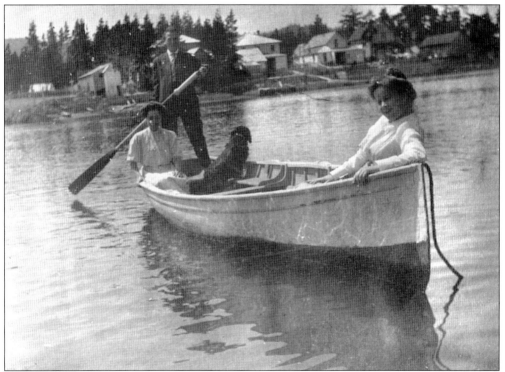
The Necanicum River provided many activities for tourists and locals alike. Here Irwin Felix Morrison, Nellie Arestadt Morrison, and a friend enjoy a boat ride on the river. (Courtesy of Joan Luper.)

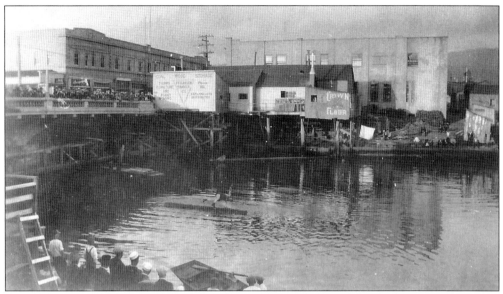

Log rolling, pictured here as part of the July 4, 1924, celebration, was another sport that often occurred on the Necanicum River near the Broadway Drive Bridge. (Courtesy of the Seaside Historical Society.)

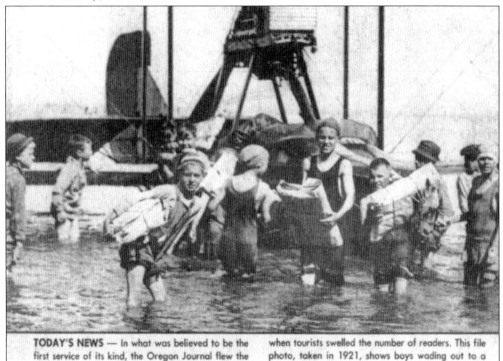

TODAY'S NEWS — In what was believed to be the first service of its kind, the Oregon Journal flew the newspaper to Oregon beaches during the summer, when tourists swelled the number of readers. This file photo, taken in 1921, shows boys wading out to a seaplane to unload the bundles.

The Necanicum River was the landing site for the floatplane bringing the *Oregon Journal* in June 1921. It arrived at 2:30 p.m. Two of the boys pictured are George Dixon (second from left) and Vern Raw (fourth from left). Also in June 1921, an announcement was made that a Curtiss F hydroplane would begin passenger service from Seaside.

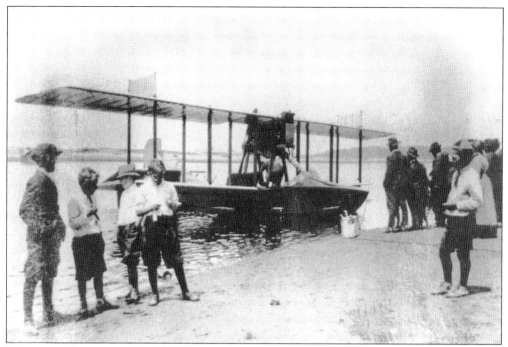

Here is another view of the plane on the Necanicum River. The first seaplane to land in the Necanicum River was noted in the *Seaside Signal* on March 9, 1920. It was piloted by Victor Vernon of the Oregon-Washington-Idaho Airplane Company. (Courtesy of the Seaside Historical Society.)

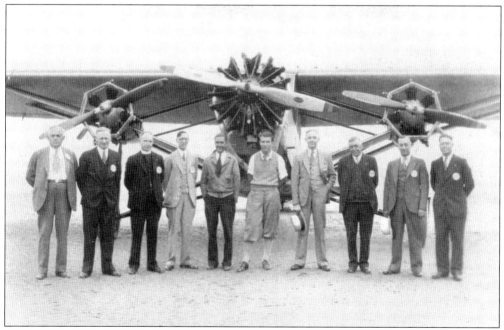

Pictured on the beach with a trimotor plane second from the left to the right are L. J. Klink, Father Nielson, Bob Beckman, Frank Kerr, unidentified (possibly the pilot), Mr. Aherns, John Blake, Chet Groat, and Mitch Thorn.

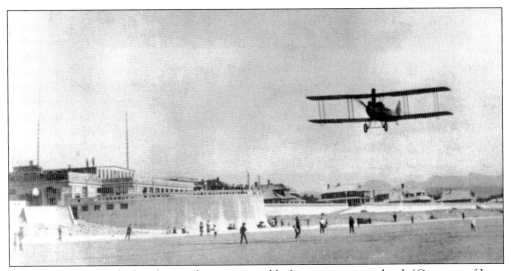

A biplane flies over the beach past the turnaround before coming in to land. (Courtesy of Jerry Turner, Nostalgic Reflections.)

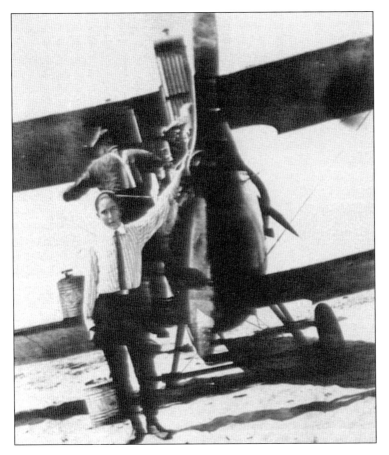

Here Mason Hall watches Ted Rankin's plane. Ted Rankin gave flights from Seaside Beach at Twelfth Avenue. For an aerial view of Seaside, flights were $3 per person. Later the price became $5 for a 15-minute ride with two people in the backseat. The wires on the plane would scream and vibrate as it flew.

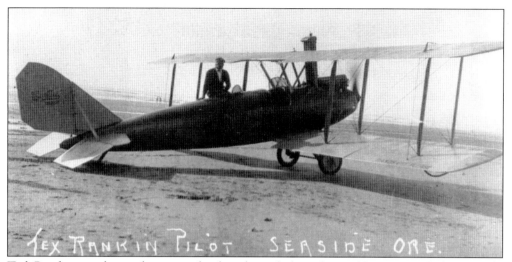

Ted Rankin is shown here on the beach with his plane. (Courtesy of the Seaside Historical Society.)

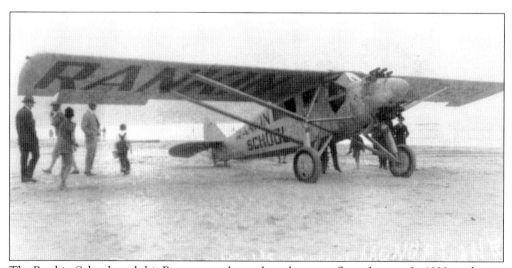

The Rankin School used this Ryan monoplane when they gave flying lessons. In 1930, at the age of nine, Maj. Gen. Douglas T. Nelson went on a $5 flight in a Waco off Seaside Beach. He went on to become a decorated U.S. Army Air Corps pilot. (Courtesy of the Seaside Historical Society.)

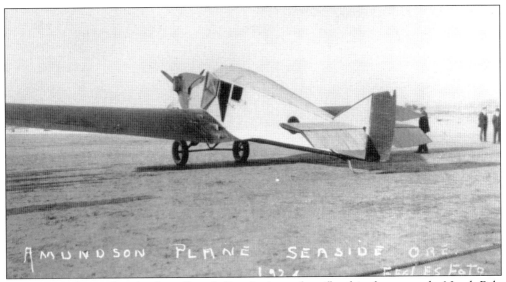

Roald Amundson's plane lands on Seaside Beach. Amundson flew his plane over the North Pole in 1926. (Courtesy of the Seaside Historical Society.)

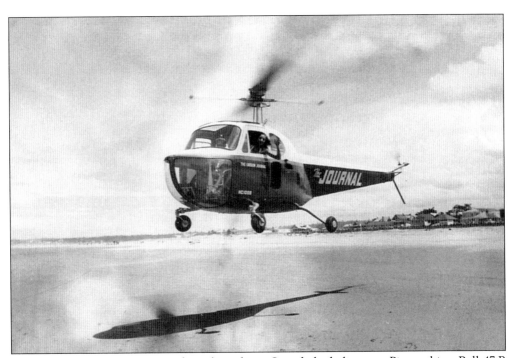

In later years, the *Oregon Journal* was brought to Seaside by helicopter. Pictured is a Bell 47-B helicopter. (Courtesy of Edna Marie Thorn.)

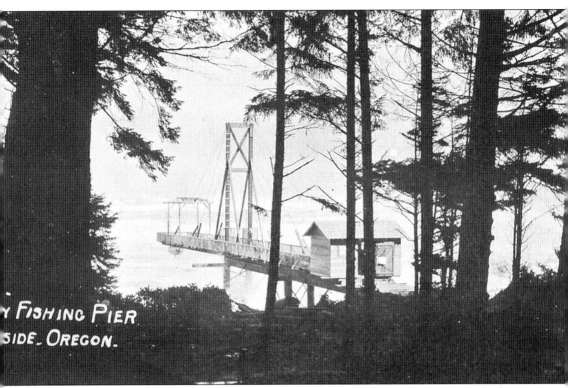

A fishing pier of heavy, squared timbers on a foundation of concrete-filled iron pipes was built at the cove at the south end of Seaside in 1929. It was washed away by a storm that fall, and in the spring of 1930, a cantilever-style pier was constructed in the same location by William Kinney. This pier was swept away in February 1931. (Courtesy of Edna Marie Thorn.)

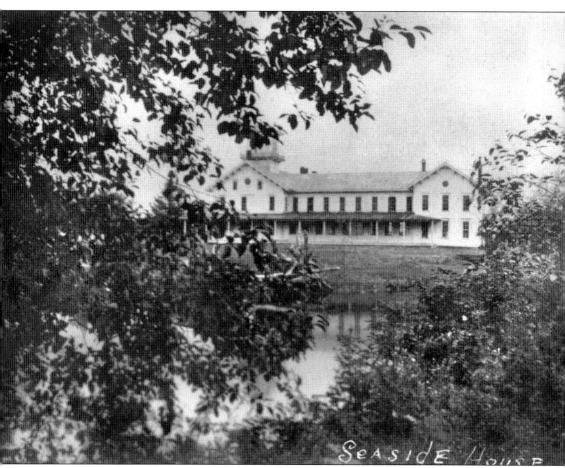
At the south end of Seaside was Seaside House, the resort originally built by Ben Holladay from which the town derived its name. The Seaside House had served as a military hospital in World War I. It was dismantled, and the grounds were purchased for the construction of the Seaside Golf Course. (Courtesy of the Seaside Historical Society.)

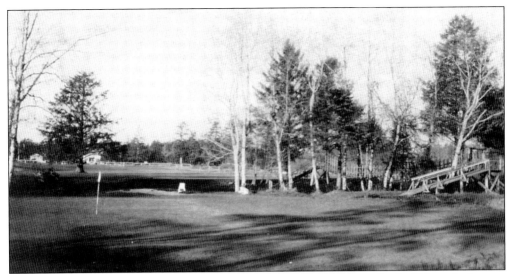

At its grand opening in 1923, the Seaside Golf Course boasted 2,593 yards of golf from the longest tees and had a par of 35. The course was designed by H. Chandler Egan. (Courtesy of the Seaside Historical Society.)

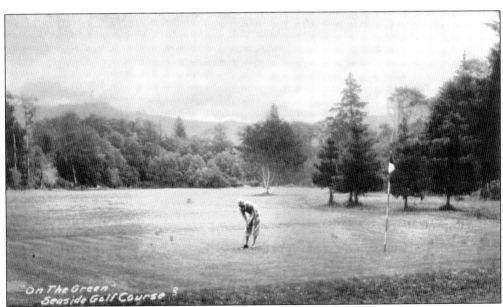

The Seaside Golf Course provided some of the most scenic links on the Oregon coast during the first half of the 19th century. Here a golfer prepares to putt in this verdant setting. (Courtesy of the Seaside Historical Society.)

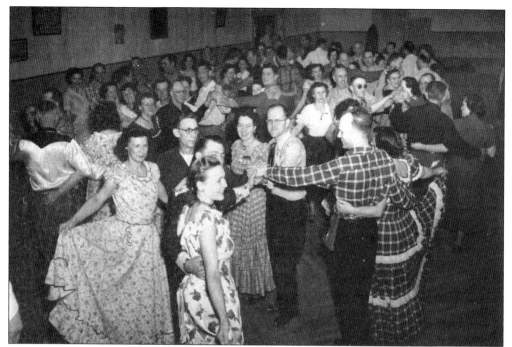

The natatorium at the turnaround had a skating rink and was the site of another dance hall. The local square dance group held their graduation there in 1950. From left to right in the foreground are Lucille and Del Bradburn, Alice and Les Hermann, Nooney Avery, Vern and Jean Burke, and Chuck Smith. (Courtesy of Alice Hermann.)

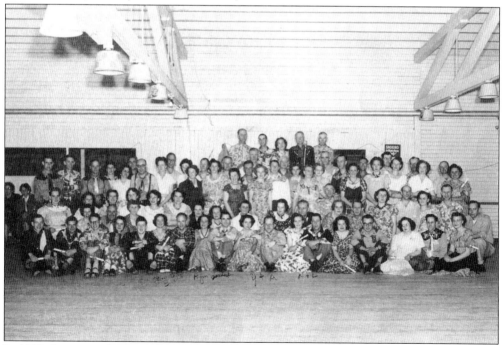

In 1950, the square dance graduation class is seen at the Trails End at the turnaround. (Courtesy of Alice Hermann.)

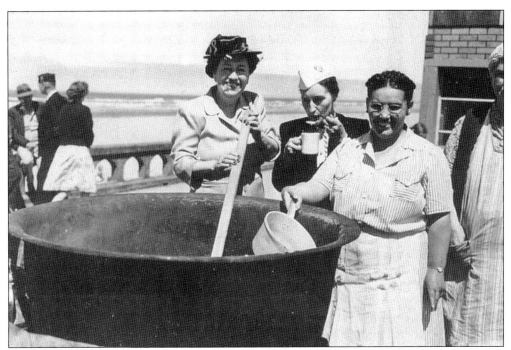

Clam chowder cook-offs and chowder feeds are another part of Seaside's history. Here Wilda Thorne and Blanche Ruthrauff pose with the chowder kettle. (Courtesy of Edna Marie Thorn.)

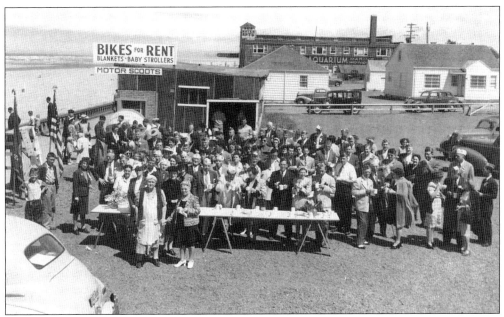

Tourists and locals waiting for chowder on the beach near the aquarium. (Courtesy of Edna Marie Thorn.)

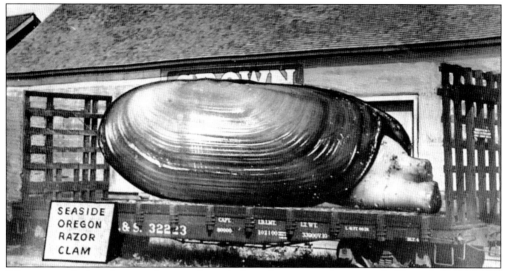

The size and abundance of razor clams led to this comical postcard. (Courtesy of Lester Raw II.)

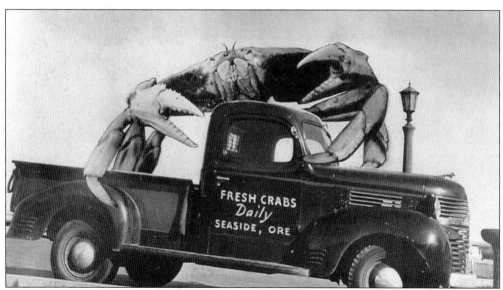

Fresh crabs were also plentiful. Another comical postcard showing their size was made at the Montag Photo Shop. (Courtesy of Lester Raw II.)

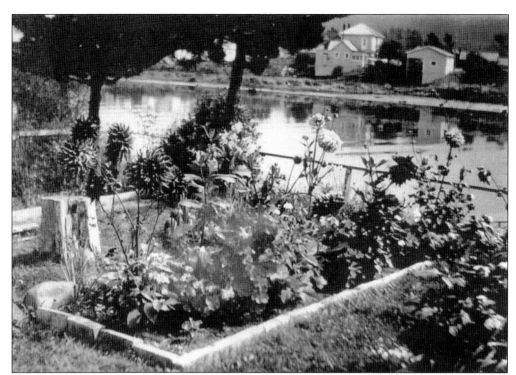

Dahlias have grown well in Seaside and for many years were the focus of a grand festival. These specimens grew in a garden at the home of Thomas Benton Morrison on North Franklin Street. (Courtesy of Joan Luper.)

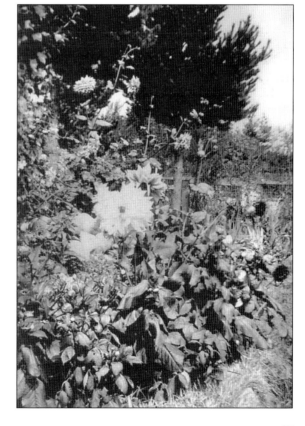

Dahlias, as large as dinner plates and often over 6 feet in height, were a common sight in gardens around the city. These were also at the Morrison home, which had a sign hanging from the front porch that read Sell-Dum Inn. (Courtesy of Joan Luper.)

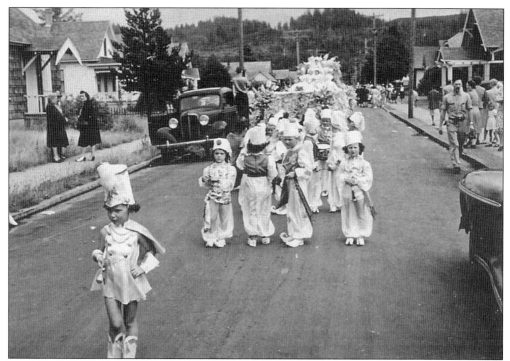

The highlight of the Dahlia-growing season was the Dahlia Parade, which began in 1912. Floats, bands, and many children's groups were included in the yearly parade. (Courtesy of Edna Marie Thorn.)

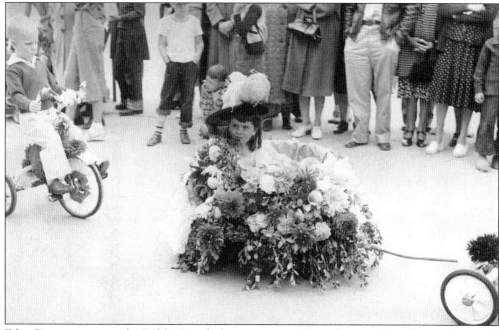

Edna Dawson oversaw the Dahlia Parade for many years. Floats, large and small, were decorated with dahlias. Following her death, it became known as the Edna Dawson Memorial Dahlia Parade. (Courtesy of Edna Marie Thorn.)

Joyce Manion is eating ice cream while riding on this float in the parade. (Courtesy of the Seaside Historical Society.)

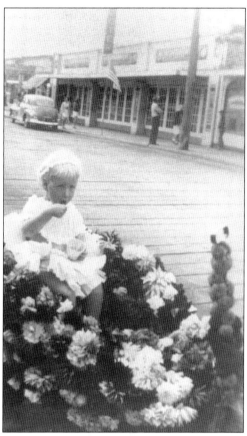

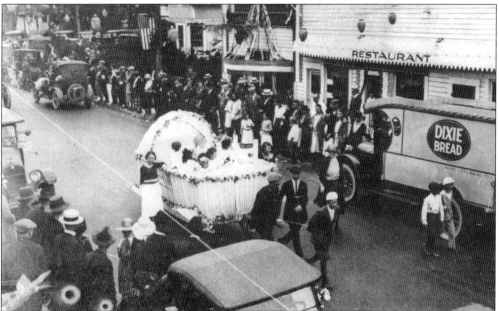

Another float from a Dahlia Parade in the 1920s passes by a Dixie Bread delivery truck on Broadway Drive. (Courtesy of the Seaside Historical Society.)

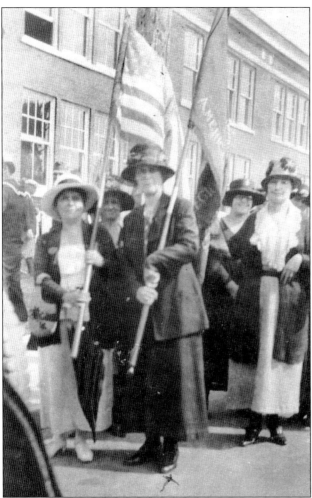

Mrs. Krohn and other ladies carry the flags in this 1923 parade for the American Legion Convention. (Courtesy of the Seaside Historical Society.)

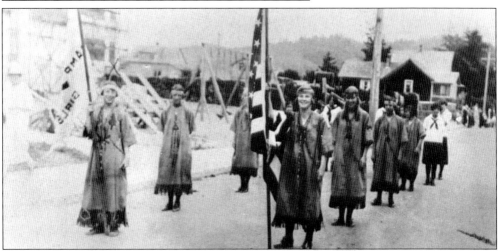

Women are dressed in Native American attire for a Lewis and Clark Festival parade. (Courtesy of the Seaside Historical Society.)

Marjorie Raw and Pauly dressed for the Lewis and Clark Festival in June 1946. (Courtesy of Lester Raw II.)

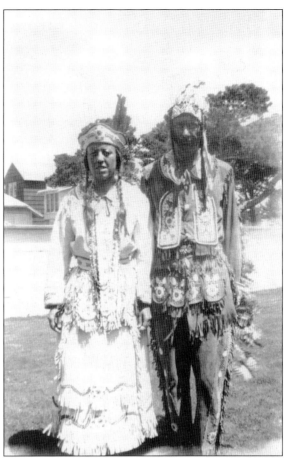

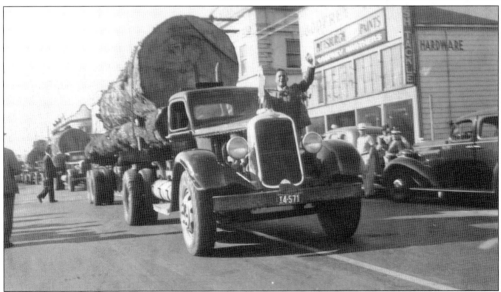

Examples of the logs taken from local forests were carried in the Western Logger's Conference Parade in the 1940s. (Courtesy of the Seaside Historical Society.)

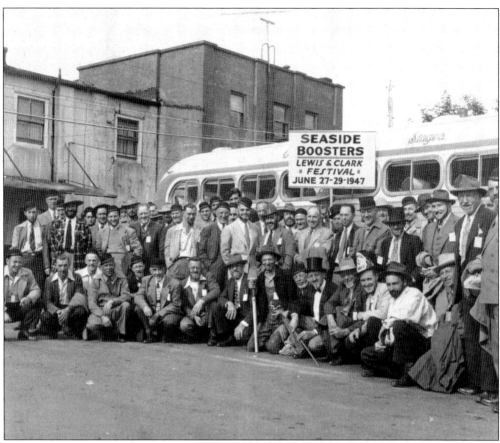

Seaside boosters gather for a group photograph during the Lewis and Clark Festival in 1947. (Courtesy of the Seaside Historical Society.)

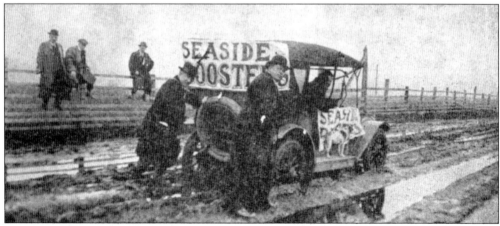

Seaside boosters Dan Moore, Howard Laighton, Earl Hurd, E. J. Oates, and Morris Martin, and Sport, the dog, head to Astoria on the "new" road in the 1920s. Highway 101 soon connected Seaside and Astoria. (Courtesy of the *Seaside Signal*.)

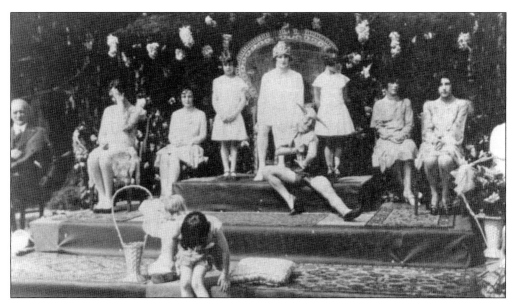

Those who crowned queen Marie Daly for the May Day celebration in 1929 included Mayor Galvani, Paul Rafter, Colleen Callahan, Helen Jandrall, Francis Wheatley, Darlene Callahan, Betty Smith, Marian McKay, Irene Soule, Lois Smith, Jane Washer, Carmen Fulkerson, Helen Haley, and Catherine Spear. (Courtesy of the Seaside Historical Society.)

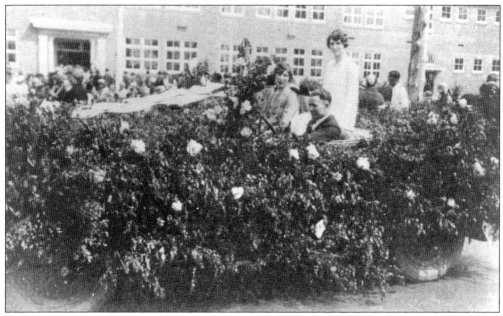

A float in the 1929 May Day parade is driven by Coach Campell with May Day queen Marie Daly and Irene Soule. (Courtesy of the Seaside Historical Society.)

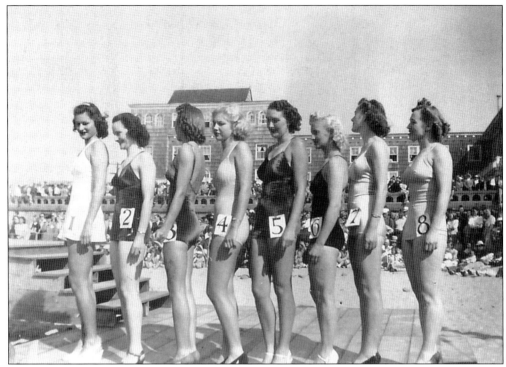

June Callahan, representing Seaside Post 99, won the statewide American Legion beauty contest conducted at the annual convention held in Seaside from September 4–7, 1940. The number on the contestants indicates final placement in the judging. In 1946, the Miss Oregon pageant began on the beach in Seaside.

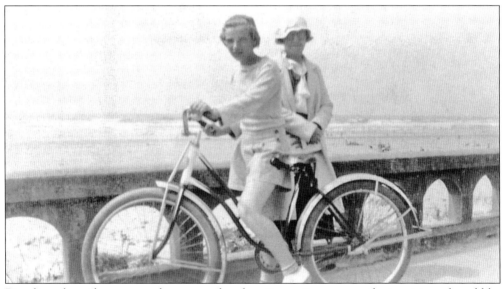

Bicycling along the promenade was another favorite pastime among the tourists and could be rented at several locations around the city. Mary Jean Kelley is seen here on a bicycle with Rosanna Kelley behind her. (Courtesy of Kathleen Grimm.)

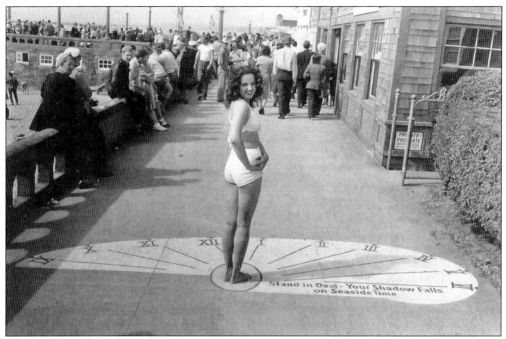

The sundial on the promenade, which was made by Tommy Ruthrauff, was a popular spot in the 1940s for pictures. If one stood in the circle, their shadow would cast a path on the time in Seaside. (Courtesy of Edna Marie Thorn.)

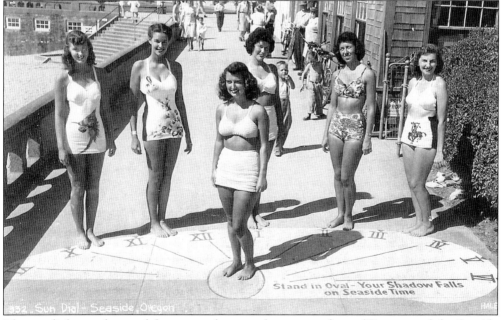

The sundial was also used for group photographs, as seen here. (Courtesy of the Seaside Historical Society.)

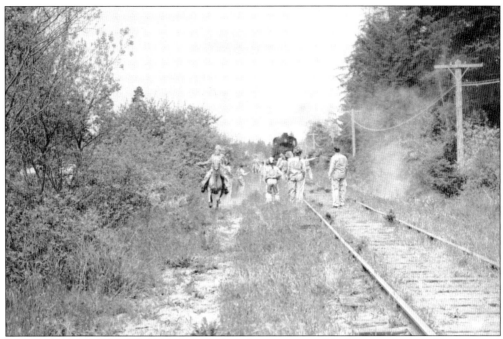

An article in the May 27, 1948, *Seaside Signal* newspaper told of a great train robbery staged when the Gull-oots stopped the SP&S train at Twelfth Avenue and boarded it. (Courtesy of Len Brooks.)

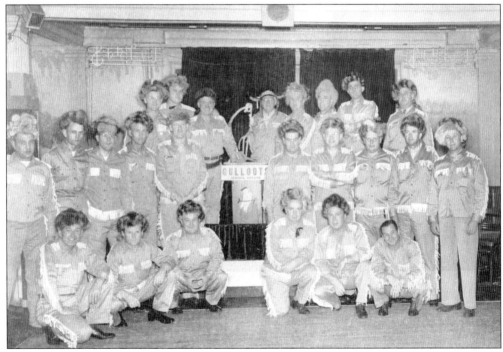

The Gull-oots were a group of Seasiders lead by Paul Scoggin whose uniforms were in the frontier style. Other members included John William Dawson and Joe Sopko. (Courtesy of Len Brooks.)

Four
WAR YEARS

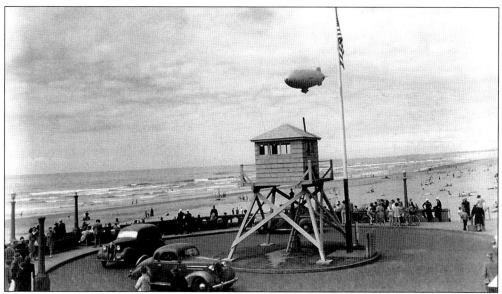

A blimp passes over the beach near the observation tower erected at the turnaround. The U.S. Coast Guard lookout tower was at the turnaround and an aircraft observation tower was located at Avenue G on the promenade from June 21, 1943, until November 13, 1945. (Courtesy of Edna Marie Thorn.)

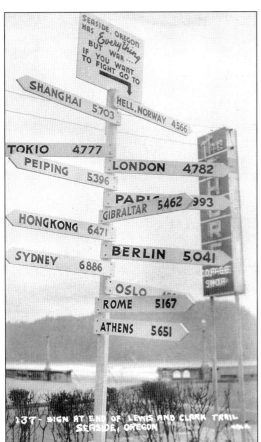

During World War II, several different signs were erected in the vicinity of the turnaround. Behind this one is the sign for the Shore Coffee Shop at the Hotel Seaside.

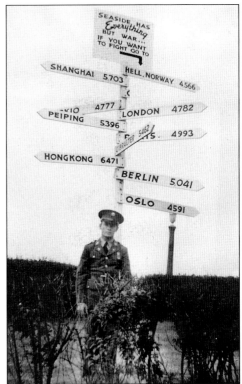

The sign provided a fitting backdrop for pictures with members of the military.

At the top of this sign is an arrow pointing toward the Pacific Ocean. (Courtesy of Hale.)

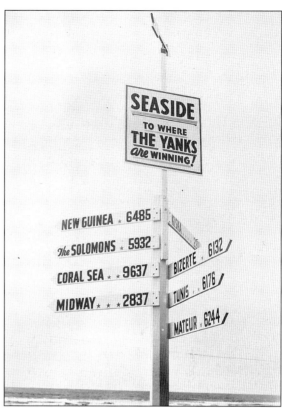

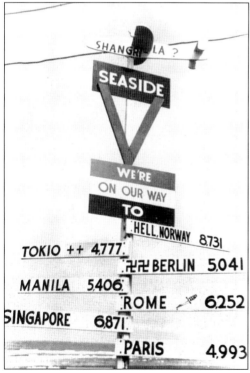

This sign is topped by an airplane. Note the dagger on the mileage to Rome.

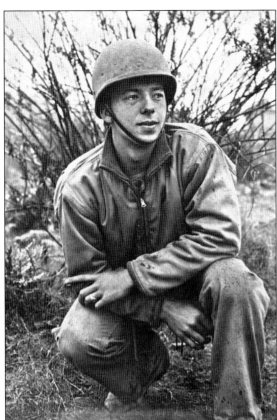

Bud Leonard, son of "Tiny" Leonard, was one of Seaside's young men who died in World War II. He was killed in the South Pacific. (Courtesy of Edna Marie Thorn.)

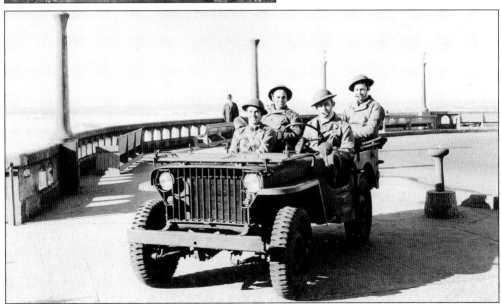

Seaside's close proximity to Fort Stevens allowed many of the townspeople to hear and feel the bombs that landed near the fort when it was fired upon. The military who patrolled the area were often seen in their jeeps driving around the turnaround. The area was especially patrolled at night. (Courtesy of Edna Marie Thorn.)

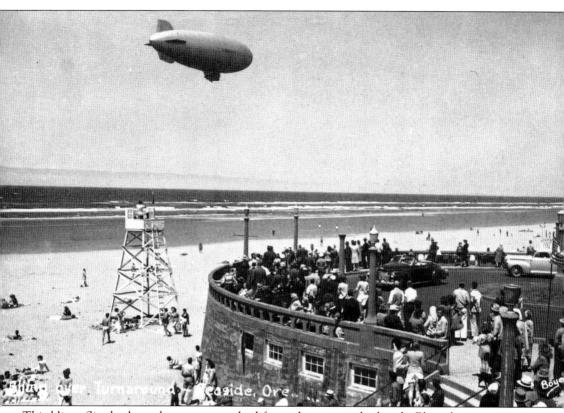
This blimp flies back up the coast over the lifeguard tower on the beach. Blimp hangers were located at the Astoria airport and in Tillamook. (Courtesy of Edna Marie Thorn.)

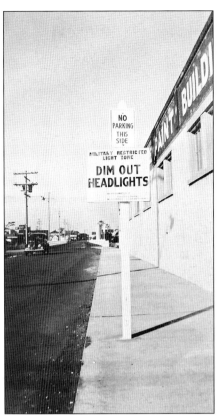

Signs were posted reminding drivers to dim their headlights at night as sections of the town were in the military restriction zone. Blackouts were necessary for the safety of the community. (Courtesy of Edna Marie Thorn.)

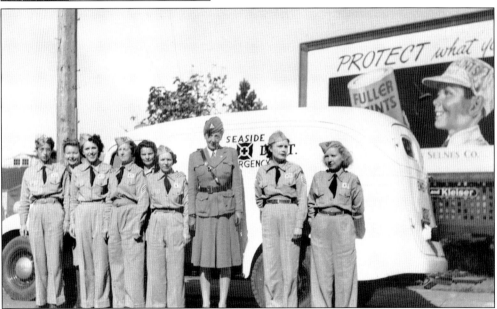

Many women joined the Women's Ambulance Corps. Pictured here in 1943 is one group photographed at Seaside. From left to right are Virginia Roehm Raymond, Iva Barder, Virginia Peron, Sandy Morehouse, two unidentified, Lt. Eleanor Napier, Gladys Gaskel, and unidentified. (Courtesy of the Seaside Historical Society.)

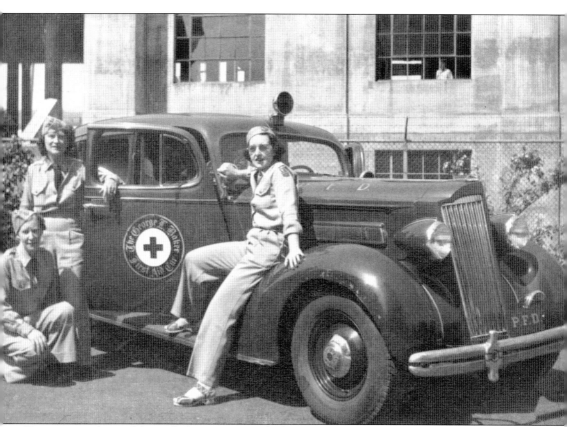

Here are members of the ambulance corps with the George T. Baker first-aid car. (Courtesy of the Seaside Historical Society.)

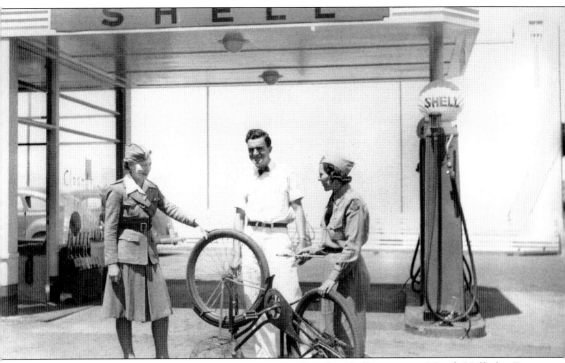

Two members of the ambulance corps are pictured at the Shell station on North Holladay Drive with Ed Nimmo having a bicycle tire repaired. Bicycles, as a mode of transportation, were common during gas rationing. (Courtesy of the Seaside Historical Society.)

Five

PEOPLE

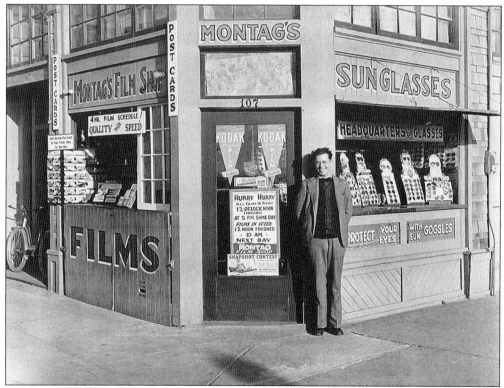

What is a history without the people who made it? In the previous chapters, some have been introduced but many have been left until the end. The photographs of William Montag and Leslie Hale helped to track the history of Seaside. Montag's Film Shop at the turnaround is seen here in 1939 with Leslie Hale standing in the doorway. Hale purchased the shop in 1940 and carried on the tradition of photographing the tourists, residents, and happenings in the town. (Courtesy of Edna Marie Thorn.)

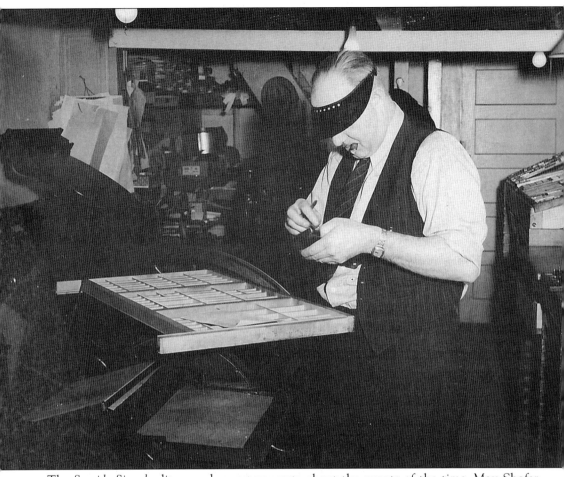
The *Seaside Signal* editors and reporters wrote about the events of the time. Max Shafer, editor from 1928 to 1974, is pictured setting type for an issue of the paper. (Courtesy of Edna Marie Thorn.)

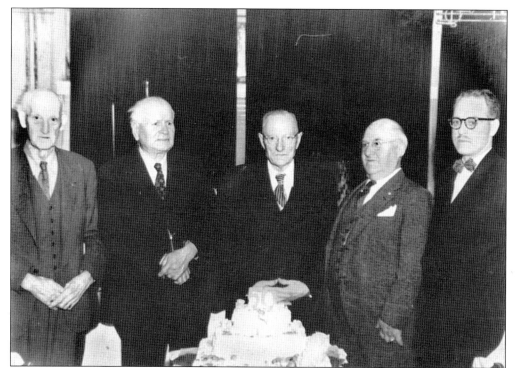

The City of Seaside celebrated its 50th birthday in 1949 with a dinner celebration. Mayor Lester Raw Sr. (far right) was the host; he served as mayor from 1948 to 1960. Other former mayors present were, from left to right, Jake Brailler, Alex Duncan, E. T. Stafford, and Lee Coffman. (Courtesy of Vern Raw.)

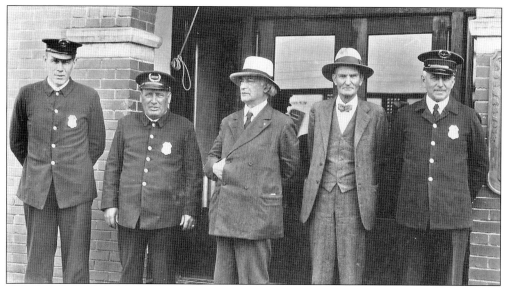

The 1931 Seaside city officials standing on the steps of city hall are, from left to right, Harry Kemmerer (police chief), Richard A. Brown (marshal), Mayor Galvani, Edwin S. Abbott (auditor and police judge), and Sid Smith. (Courtesy of Edna Marie Thorn.)

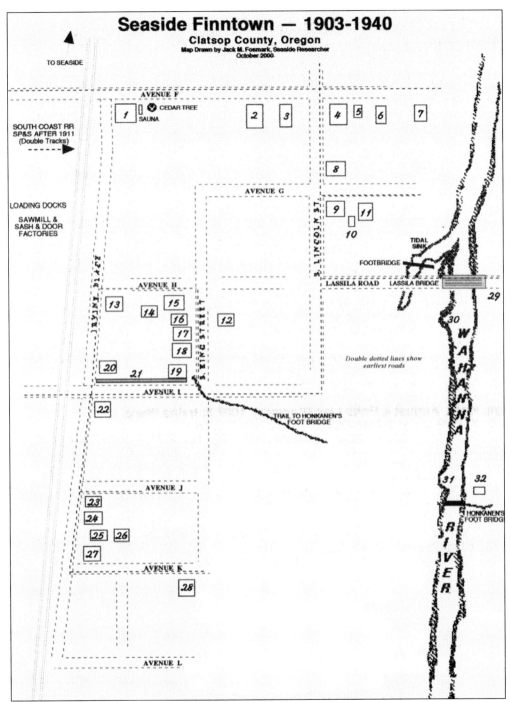

Seaside Finntown 1903–1940 located on the east side of Roosevelt Drive and the Spokane, Portland and Seattle railroad tracks. This area was called Finntown because the inhabitants all came from Finland. Many later purchased land from John Sunquist and built farms. There was another, smaller Finnish community in the town of Gearhart, north of Seaside. (Map courtesy of Jack Fosmark.)

ORIGINAL RESIDENTS & ADDRESSES

1. HELSTROM, John F. & Maria J., 941 Ave. F.
2. MANNILA, Herman & Milga (Maki), 1021 Ave. F.
3. AHO, Herman & Hilda (house later numbered 1110 Ave. F East)
4. HENDRICKSON, Eric & Sandra (Gronholm), 1103 Ave. F.
5. HANSON, Hugo & Lempi (Honkanen), Tillamook Rock LighthoUSE Keeper.
6. SEASIDE FINNISH SOCIALIST HALL, 1109 Ave. F.
7. FISHER, Henry "Heiny" & Caroline, 1115 Ave. F.
8. NEWMAN, John (later residence of Bill HENDRICKSON), 651 S. Lincoln St.
9. SALMEEN, Isaac & Helena, 721 S. Lincoln St.
10. "ALTO'S CABIN" (Niemi family used when their house burned,1926)
11. ALTO, Frank Nestor & Hilma (Mattila), 1109 Ave. G (now 1115 Ave G)
12. Widow Selma Niemi's barn.
13. Non-Finn residents; very old house.
14. ROSS, Victor (ROSBLOM in Finland), 924 S. King St.; His wife, Helene ROSBLOM, and two children, Salfi and Viktor, when returning from a visit to Finland, died in the sinking of the Titanic, April 14, 1912. Victor and son Eino survived (had not gone on the trip)
15. NIEMI, Jonas "John" & Selma (Palojarvi), 920 Ave. H.
16. Burned down May 1926, when occupied by Selma Niemi.
17. HENSALA, Herman & Mina "Minnie" (Parvesta?), 800 S. King St.
18. SALVON, Henry & Hannah Sophia (Kinnunen), 816 S. King St.
19. HONKANEN, Oney Andrew Sr. & Ida Marie, 920 Ave. I.
20. KRAL (Before 1915, non-Finnish millworkers)
21. Plank sidewalk constructed by Honkanen.
22. NIEMI, Eino J., 901 Ave. I. (Built 1937).
23. SILVES, before 1906. SOMPPI (or Sumppi), later.
24. KARI, August & Priita Lisa (Kamara), 1007 S. Irvine Place.
25. KOSKI, John & Elsa (Kari), 1015 S. Irvine Place.
26. First Jonas & Selma Niemi house (son Eino Niemi born here 1909).
27. WAHLMAN, Gustav & Amanda, 820 Ave. K. One of earliest Finntown residents; a "receiving station" for new arrivals from Finland.
28. ISLE, OscarWaldimer & Anna (Wiljnen), 915 Ave. K. (Moved to Hamlet,1918
29. LASSILA BRIDGE, built before 1914.
30. SKINNY DIPPING HOLE #1
31. SKINNY SIPPING HOLE #2 (BBB: "Bare Butt Bunch").
32. Honkanen's cow shed.

These are the original residents and addresses for Finntown. (Courtesy of Jack Fosmark.)

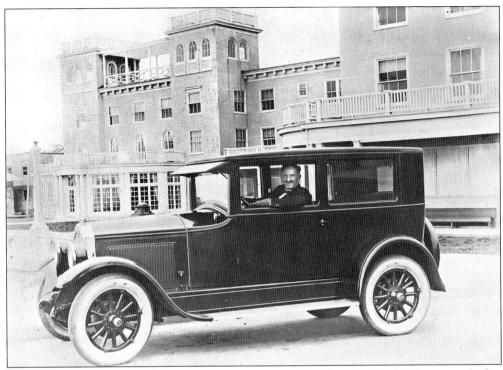

Dan Callahan drives around the turnaround in front of the Seaside Hotel. (Courtesy of Edna Marie Thorn.)

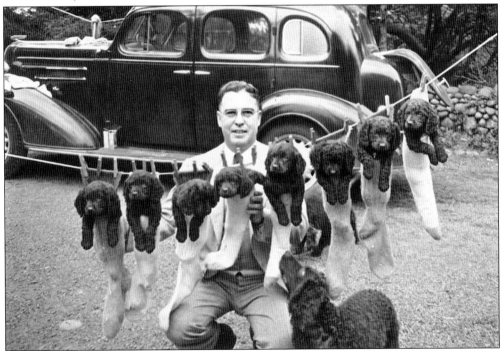

Mitch Thorn, who worked at the electric company, is pictured here with a litter of puppies. (Courtesy of Edna Marie Thorn.)

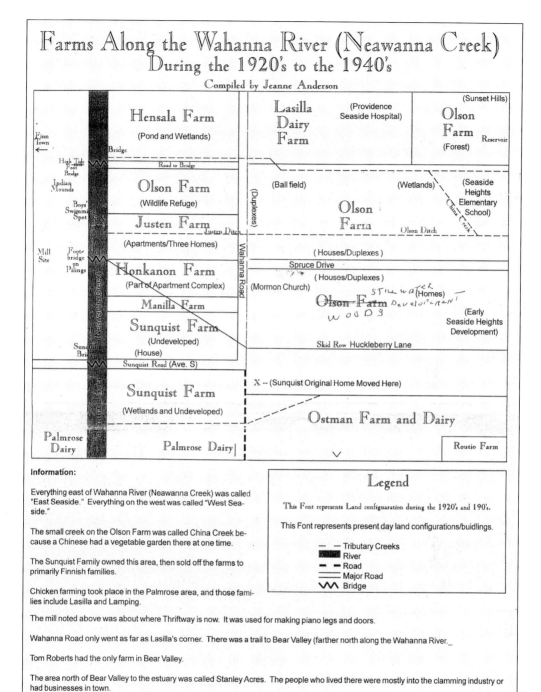

Pictured here are the farms along the Wahanna River (Neawanna Creek) during the 1920s through the 1940s (as compiled by Jeanne Olson Anderson). The next group of pictures includes these families.

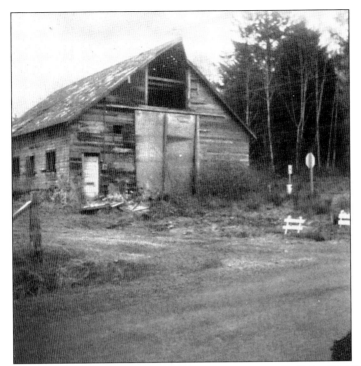

Seen here is the barn at the Olson dairy farm before it was torn down. Mary Ellen Olson had 21 cows and each had a name. She tended to them in the barn herself as it gave her "quiet time" away from her children. (Courtesy of Harold Lampe.)

On the beach are, from left to right, Andy Lassila, unidentified, and John Lassila. Andy had an ice cream stand by the Broadway Drive Bridge. He was also referred to as an alleged bootlegger during Prohibition. The Lassila farm was located on acreage next to the Olson farm.

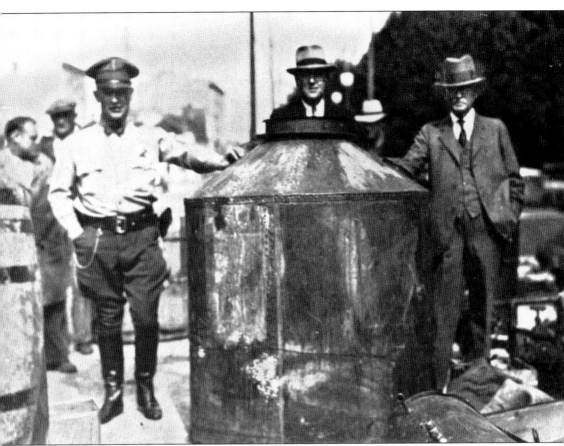

From left to right are state police sergeant Ken Healea, deputy sheriff Paul Kearney, and Sheriff Jack Burns with a confiscated whiskey still taken in Seaside during the 1920s. Tales of bears were told to neighborhood children to keep them from the woods where the stills were in operation.

Seen here is the Lampe home and family. They owned a chicken farm. (Courtesy of Harold Lampe.)

Pictured here is the Ostman family in a field in front of their dairy farm. The house and barn are still standing, although no longer occupied by the Ostman family. (Courtesy of Harold Lampe.)

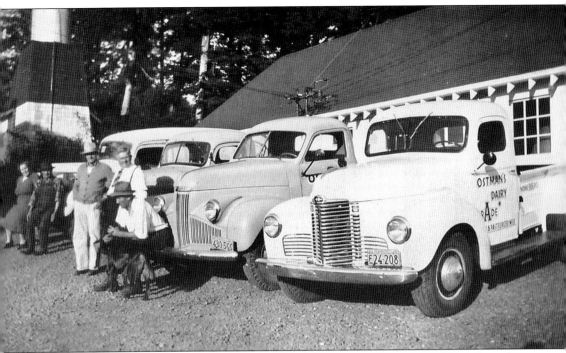

Milk trucks delivered milk from the Ostman farm throughout the community. Water from the creek was so pure it was used at the dairy as recently as 1948. (Courtesy of Harold Lampe.)

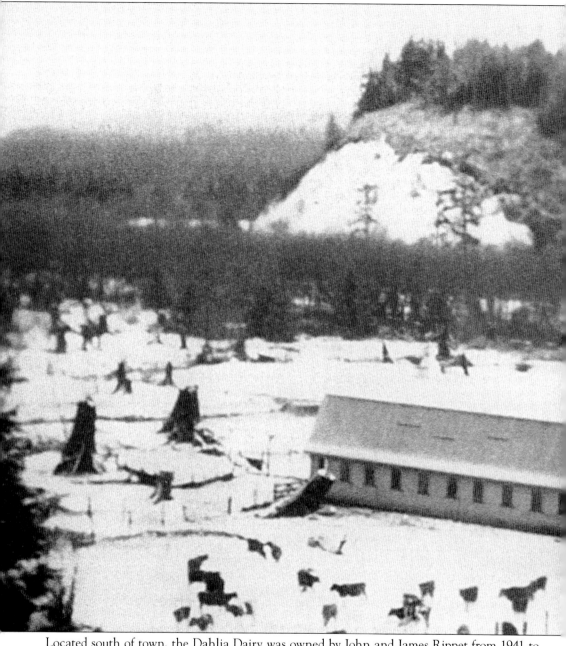
Located south of town, the Dahlia Dairy was owned by John and James Rippet from 1941 to

1960. (Courtesy of Ed Rippet.)

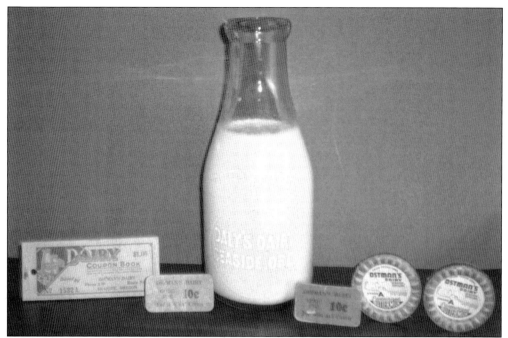

Milk bottle caps, a coupon book, and milk coupons from the Ostman dairy, as well as a milk bottle from the Daly Dairy, were found at local antique shops. Frank Daly bought the Sunquist Dairy in March 1925.

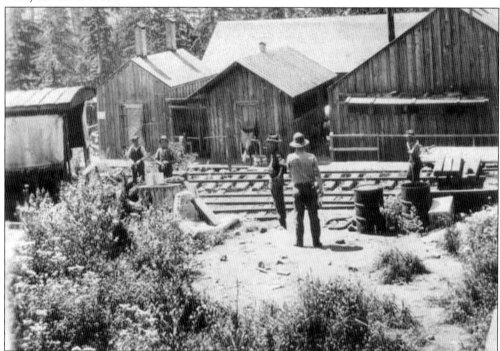

Logging was an important industry in the area, and there were many logging companies in the forests surrounding the community. Pictured here is the Milton Creek Logging Company in 1923. (Courtesy of the Seaside Historical Society.)

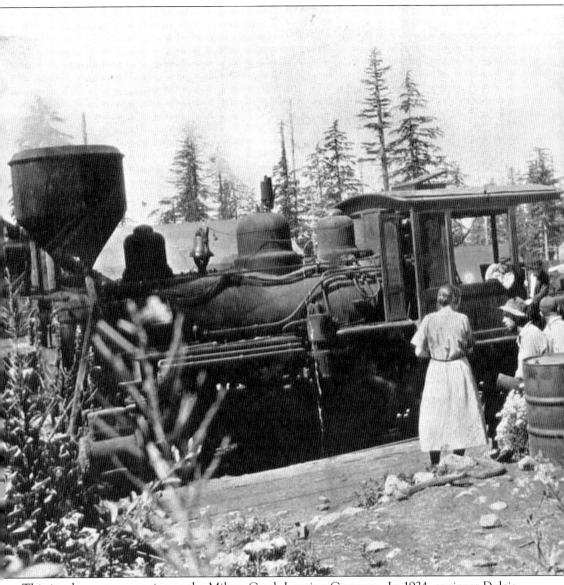
This is a large steam engine at the Milton Creek Logging Company. In 1924, engineer Dulcie Hemminger was killed in a logging accident here. (Courtesy of the Seaside Historical Society.)

Ed Poole built a candy store in 1897 at 211 Broadway Drive, and later a bowling alley. One could bowl "10 frames for 15 cents a line." He built a new bowling alley in 1924. His store was eventually sold to Duncan "Dan" Stewart and later to John Phillips. Phillips Candy Store is still in operation today. (Courtesy of the Seaside Historical Society.)

Duncan "Dan" Stewart hired Margarita Blake for her first summer job in 1926 and taught her to dip chocolates. She married John Phillips, who purchased the candy store in 1939. The name was changed to Phillips Candy Store in 1947. (Courtesy of Frank Stewart.)

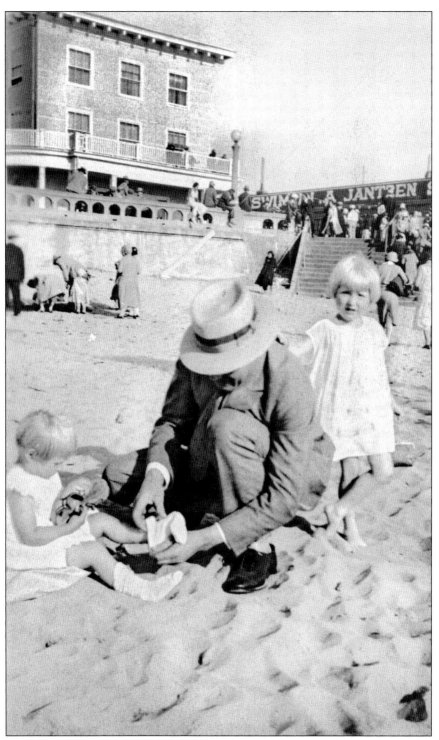

Pictured are, from left to right, Betty Hill, George Hill, and Mary Hill, who have been playing on the beach at the turnaround. However, it is now time to shake off the sand and put their shoes back on. (Courtesy of Mary Cornell.)

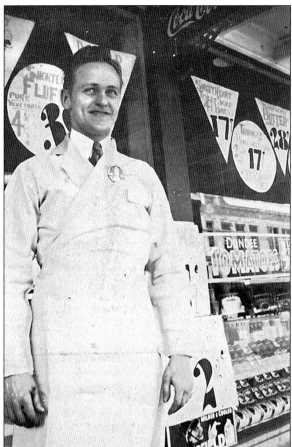

A. R. Wascher owned a grocery store at 611 Broadway Drive. The small grocery was later run by his son. Wascher was remembered as being very cheerful and gave a bag of hard candy to customers when they settled their accounts. The store was founded in 1908 as Washer and Dresser. (Courtesy of Frank Stewart.)

Erwin Felix Morrison stands along the Necanicum River behind the Sell-Dum Inn. This home was located about 617 North Franklin. (Courtesy of Joan Luper.)

Erwin Felix Morrison and Ruth Hunter were married in Seaside in 1921. Erwin was the county constable from 1937 to 1952. Ruth, Erwin's second wife, owned Ruth's Mayonnaise Kitchen. (Courtesy of Joan Luper.)

This is Joan Blakeley, great-great-granddaughter of Cecust, the first Native American to be given a land grant. She owned 340 acres from Tillamook Head to about where Avenue G is in Seaside. (Courtesy of Joan Luper.)

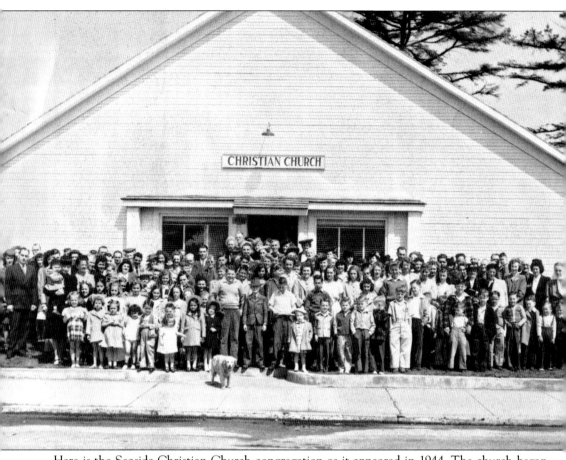

Here is the Seaside Christian Church congregation as it appeared in 1944. The church began meeting in a livery stable on Avenue A in 1944. In 1945, they bought a lot at Fourteenth Avenue and Holladay Drive to build a church. They are currently located on Delmoor Loop in Warrenton. William Morris was the first minister. (Courtesy of the Seaside Christian Church.)

This photograph is of the Christian Women's Group in 1946. This group was called the Loyal Workers in 1946 and later the Christian Women's Fellowship. They raised money by giving suppers. They worked with the women of the Baptist church and the Assembly of God rolling bandages and also making hospital gowns from shirts for leper colonies. (Courtesy of Seaside Christian Church.)

Here are Ed Bowser and Bill Morse with Fred Hatchell in 1949. Ed had a service station on Avenue G for many years. Fred Hatchell was a minister at Seaside Christian Church. Bill Morse and his wife came from Newburg, Oregon, to serve as evangelists. (Courtesy of the Seaside Christian Church.)

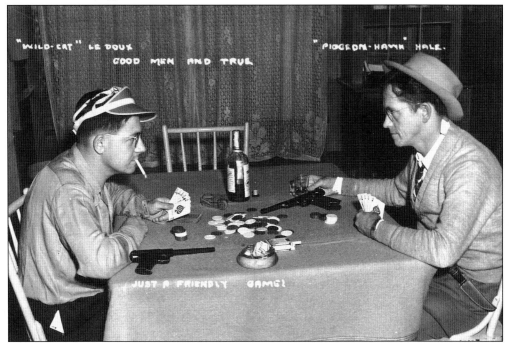

Card games were often held in the rooms above the billiard hall. Here, in a comically staged photograph, "Wildcat" LeDoux and "Pigeon Hawk" Leslie Hale have a friendly game of poker. (Courtesy of Edna Marie Thorn.)

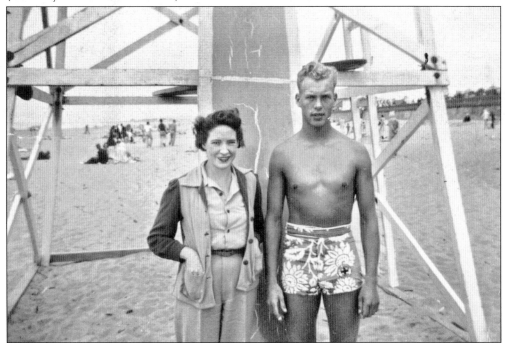

Here are Olive and Harry Wahlstrom standing on the beach by the lifeguard station. Harry was a B-17 pilot in World War II and the principal at Broadway Drive School for many years. (Courtesy of Lester Raw II.)

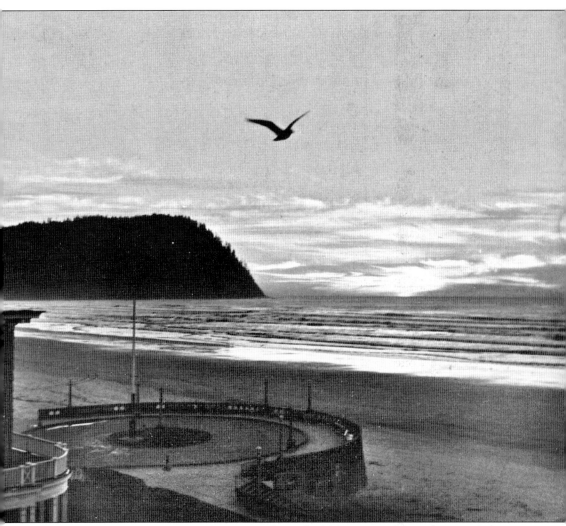

As the seagull flies out over the Pacific Ocean, the end of this journey has come. Seaside has continued to grow and prosper and is still a prime tourist destination on the Oregon coast. (Courtesy of the Seaside Historical Society.)

ACROSS AMERICA, PEOPLE ARE DISCOVERING SOMETHING WONDERFUL. *THEIR HERITAGE.*

Arcadia Publishing is the leading local history publisher in the United States. With more than 3,000 titles in print and hundreds of new titles released every year, Arcadia has extensive specialized experience chronicling the history of communities and celebrating America's hidden stories, bringing to life the people, places, and events from the past. To discover the history of other communities across the nation, please visit:

www.arcadiapublishing.com

Customized search tools allow you to find regional history books about the town where you grew up, the cities where your friends and family live, the town where your parents met, or even that retirement spot you've been dreaming about.